SECRET
NEWPORT

Andrew Hemmings
with photographs from
David Swidenbank

AMBERLEY

About the Author

Andrew Hemmings lives in Newport. He has co-authored *From Lancashire to Yorkshire by Canal* with David Swidenbank. Andrew has an abiding interest in industrial archaeology, railways and maritime matters. He is a Fellow of the Chartered Institute of Logistics and Transport.

To Emily, Bethany and Milena

First published 2017

Amberley Publishing
The Hill, Stroud
Gloucestershire, GL5 4EP

www.amberley-books.com

Copyright © Andrew Hemmings, 2017

The right of Andrew Hemmings to be identified as the Author of this work has been asserted in accordance with the Copyrights, Designs and Patents Act 1988.

ISBN 978 1 4456 6326 5 (print)
ISBN 978 1 4456 6327 2 (ebook)

British Library Cataloguing in Publication Data.
A catalogue record for this book is available from the British Library.

Origination by Amberley Publishing.
Printed in Great Britain.

Contents

Introduction

'*Terra Marique*', the motto on the coat of arms for the city of Newport in South Wales, formerly Monmouthshire and Gwent, translates as 'By land and sea'. It refers to Newport's position as a port, firstly at Caerleon with the Roman settlement, then on the banks of the River Usk and finally the creation of docks at the mouth of the river. The whole essence and spirit of Newport is inextricably bound up with water in the shape of the river, canal and the sea.

The name itself doesn't appear to contain any secrets, but masks a dual and sometimes covert identity. The settlement of Newport is first mentioned as '*novo burgus*' established by Robert, Earl of Gloucester, in 1126. The name was derived from the original Latin '*novus burgus*', meaning 'new borough' or 'new town', presumably to distinguish it from the older Roman settlement of Caerleon. To separate it from the plethora of places called Newport across Great Britain, it was sometimes labelled as Newport-on-Usk. Subsequent elaborations used supplements of Monmouthshire, Gwent and South Wales, all of which are correct, depending upon the historical context. It may be more helpful to use the Welsh language name for the city, Casnewydd, which means 'New Castle'. This is the shortened version of Castell Newydd ar Wysg and refers to the twelfth-century castle ruins facing the River Usk.

The civic coat of arms gives further clues to Newport's secret history. The shield is that of the Staffords, earls and dukes of Buckingham, and lords of the manor of Newport in the fourteenth and fifteenth centuries. Allegedly, the rescued chevron (inverted V-shape) marks the difference between the borough arms and those of the family. As outlined in chapter one, Historic Newport, there is some evidence that the Stafford coat of arms was used to commemorate the victory of archers from Newport at the Battle of Crécy in 1346. In the

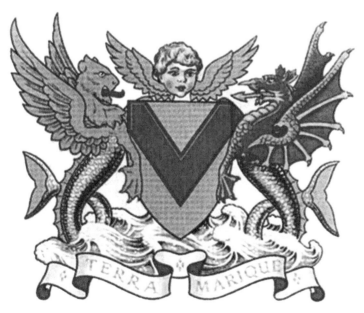

City of Newport coat of arms.

twentieth century, John Squire, guitarist of the Stone Roses, designed the cover of their hit single 'Love Spreads' based on a photograph of a cherub and shield on Newport Bridge. This led to avid fans of the Stone Roses raiding the bridge for souvenirs as the cherub design was found on many pieces of *Second Coming* merchandise, the album from which 'Love Spreads' is taken.

Less peaceful raids are depicted in the set of Civic Centre murals by Hans Feibusch. The murals are 'unsurpassed in grandeur and achievement ... and represent civic pride and a reference point for contemporary commissioning [of murals]'.

The story of Newport is told by the murals and starts with Celtic and Roman settlements, the coming of Christianity, the burning of the castle by Owain Glyndwr, the Chartist riot, the steelworks and the arrival of the Americans during the Second World War. The murals, safely housed in the Civic Centre, provide an excellent starting point for exploring the secrets of Newport.

In this book, I wanted to bring out interesting aspects of Newport's history. It has not been possible to include everything, as that would require many volumes. My aim has been to spark the interest of Newportonians and visitors alike, to enjoy the present city with the knowledge of its bewitching past.

Panoramic view.

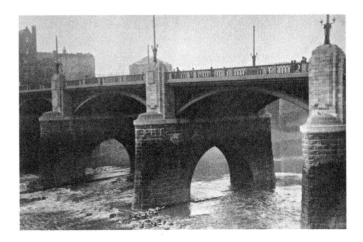

Newport Bridge.

1. Historic Newport

Caerleon – Lost City of the Legion

Caerleon was home to the 2nd Augustan Legion for some 200 years and the legionary fortress of Isca, as it was then known, was one of the most important military centres in Britain. There was a large civil settlement surrounding it, and while recent archaeological excavation suggests that though Caerleon was clearly a fortress, more work will be needed to determine whether it is also right to call it a city.

Over the centuries, Caerleon (Welsh: Caerllion) was known by a number of names and has been a centre of legion, legend and literature; sometime port, fort and Roman settlement; eulogised by Geoffrey of Monmouth; referenced by Thomas Malory; idealised by Arthur Machen; a suitable place to sit and write for Alfred, Lord Tennyson; and a safe haven for Spanish children traumatised by war.

Isca (as Caerleon was originally known) was founded in AD 74 or 75 by the 2nd Augustan Legion during the final campaigns against the fierce native tribes of western Britain, notably the Silures in South Wales who had resisted the Romans' advance for over a generation. This site was chosen as it was as far inland as Roman ships could bring supplies; it was the furthest outpost of the Roman Empire and would guard the region for the next 200 years. Caerleon was one of only three permanent legionary fortresses in Britain – the other two being York and Chester.

There are four major sites to visit in Roman Caerleon: the Fortress Baths, the legionary barracks, the amphitheatre and the National Roman Legion Museum. The first of these located in the High Street uses twenty-first-century technology to bring the past to life. The baths include all the facilities expected at a leisure complex – think spa, gym and pool in Roman times – and were available to the 2nd Augustan Legion and other residents of Isca. Heated changing rooms, cold and warm baths, covered exercise rooms and an open-air swimming pool were all provided at this seemingly remote outpost of the empire.

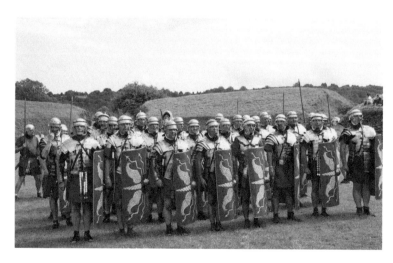

Ermine Street Guard in the amphitheatre at Caerleon.

Caerleon also has the only Roman legionary barracks visible in Europe, and one of the most impressive amphitheatres in Britain, which could once seat a whole legion – up to 6,000 spectators. Sections of the Roman fortress wall still survive and can be seen near the barracks.

Isca's archaeological remains lie relatively undisturbed beneath the modern town of Caerleon, making it especially attractive to archaeologists. Recent excavations have uncovered a whole new part of the original settlement outside the fortress walls, which could be a series of official and religious buildings or part of a major harbour facilitates. These activities have featured in Channel 4s *Time Team* programme as well as BBCs *Story of Wales* with Huw Edwards.

Most spectacular of all is the Roman military re-enactment in the amphitheatre, which demonstrates armour, infantry and cavalry tactics, equipment and siege engines, such as ballistae. On occasions, there are fighting gladiators and even an appearance from the emperor, visiting his favourite legion, Legio II Augusta.

Caerleon – Place of Legends

Legend says that after the Romans left Britain, King Arthur set up court in Caerleon, a town linked with Arthur in a number of medieval texts, including: Geoffrey of Monmouth's twelfth century *History of the Kings of Britain* and the Welsh *Mabinogion*.

Gerald of Wales visited Caerleon in 1188, and was convinced that this had been King Arthur's court. In the later Middle Ages, the remains of the Roman amphitheatre were already being described as the Round Table, and in 1405, when French troops came to Wales to assist Owain Glyndwr, chronicles say that the combined Welsh and French armies encamped at King Arthur's Round Table in Caerleon.

Thomas Malory often refers to Caerleon in his famous romance *Morte d'Arthur* (1470). Alfred Lord Tennyson had a lifelong fascination with the legend of Arthur. In 1856, as he was working on his most important Arthurian work *Idylls of the King*, the Poet Laureate came to Caerleon for inspiration. He stayed at the Hanbury Arms; the window bay where he wrote is still known as 'Tennyson's window'.

'Arthur was accustomed to hold his court at Caerleon upon Usk. And there he held it seven Easters and five Christmases. For Caerleon was the place most easy of access in his dominions both by land and sea.'

From the *Mabinogion* story of 'Geraint the son of Erbin'

Hanbury Arms, Caerleon.
(Photographer unknown)

Medieval Newport

With the exception of St Woolos Cathedral described in the next chapter, finding fragments of medieval Newport's secrets requires determination and application.

The settlement of Newport is first mentioned as '*novo burgus*' established by Robert, Earl of Gloucester, in 1126. The name was derived from the original Latin name Novus Burgus, meaning 'new borough' or 'new town'. The city can sometimes be found labelled as Newport-on-Usk on old maps. The original Welsh language name for the city, Casnewyd-ar-Wysg, means 'Newcastle-on-Usk'. This is a shortened version of Castell Newydd ar Wysg and refers to the twelfth-century castle ruins near Newport Cathedral. It was buried in rubble excavated from the Hillfield railway tunnels that were dug under Stow Hill in the 1840s and no part of it is currently visible.

The new town around the settlement grew to become Newport, obtaining its first charter in 1314 and was granted a second one by Hugh Stafford, 2nd Earl of Stafford, in 1385. Friars came to Newport in the fourteenth century and built an isolation hospital for infectious diseases. After its closure, the hospital lived on in the place name Spitty Fields (a corruption of *ysbyty*, the Welsh for hospital). 'Austin Friars' also remains a street name in the city.

During the Welsh Revolt in 1402, Rhys Gethin, general for Owain Glyndwr, forcibly took Newport Castle together with those at Cardiff, Llandaff, Abergavenny, Caerphilly, Caerleon and Usk. During the raid, the town of Newport was badly burned and Saint Woolos Church was destroyed.

A third charter, establishing the right of the town to run its own market and commerce came from Humphrey Stafford, 1st Duke of Buckingham in 1426. By 1521, Newport was described as having 'a good haven coming into it, well occupied with small crays [merchant ships] where a very great ship may resort and have good harbour'. Trade was thriving with the nearby ports of Bristol and Bridgewater, and industries included leather tanning, soap making and starch making. The town's craftsmen included bakers, butchers, brewers, carpenters and blacksmiths. A further charter was granted by James in 1623.

One of Newport's oldest houses, Ye Olde Murenger House in the High Street, dates from this time. It was originally the town house of Sir Charles Herbert, the first sheriff of the new county of Monmouthshire, and is now an inn. A murenger was an official responsible for the upkeep of the town walls. The house is the unlikely fictional location for *The Man from U.N.C.L.E.*

Arriving from the east by train or by car across the Town Bridge, the observant traveller will find a rather two-dimensional castle – as if part of a medieval film set. This is the remains of Newport Castle. The demands of modern transport have almost squeezed this castle out of existence: most lies under roads and only the east side survives, sandwiched between a road and a railway bridge. However, what little remains is not without interest, and the best place from which to get an impression of its original grandeur, is halfway across the adjacent bridge, from where its position right on the bank of the River Usk can best be appreciated. The projecting central tower with its watergate or dock beneath, is the dominant feature. Flanking it are two octagonal towers with prominent spur buttresses. These mark the north and south end of the castle, from which a curtain wall ran westwards enclosing a roughly rectangular area. Outside the curtain wall was a deep moat, which filled with seawater at high tide.

The castle was built between 1327 and 1386 by Hugh d'Audele or his son-in-law Ralph, Earl of Stafford. It replaced an earlier motte-and-bailey castle on Stow Hill, near the cathedral. Newport was the headquarters of the Norman lordship of Wentloog, or Gwynlliog, which had been within the lordship of Glamorgan until 1314. The new stone castle reflected Wentloog's enhanced status as a separate lordship. The castle was of the usual medieval type, with a curtain enclosing a courtyard or ward. Towers punctuated its sides and there would have been at least one entrance gatehouse.

The next building phase was in the second quarter of the fifteenth century, when the castle was strengthened and embellished for Humphrey Stafford, who became the 1st Duke of

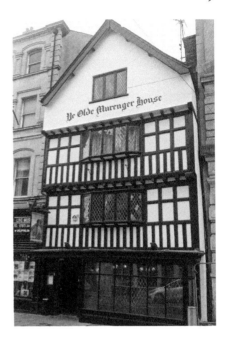

Ye Olde Murenger House, Newport.

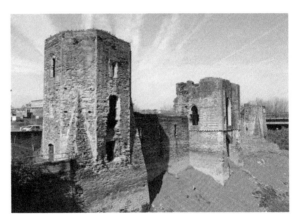

Newport Castle. (Photographer
unknown)

Buckingham. The most important of these alterations were the raising of the north curtain
wall and the heightening and modernising of the south tower. After 151, when the 3rd Duke of
Buckingham was beheaded, the castle was neglected and by the eighteenth century was mostly
ruinous. What remains of the castle has been restored in places, but much of the original
stonework of mottled pink Old Red Sandstone and white Dundry stone survives.

In the middle of the remaining castle stands the great central tower, which originally
extended further westwards. From the west, it is possible to make out all its principle features:
the watergate beneath, which was closed by a portcullis, the room above with its fine ribbed
vaulting, a spiral staircase housed in a much-restored octagonal turret in the north-west corner,
and the stub of an upper storey. The main room probably would have been the lord's audience
chamber.

To the south of the central tower was a long narrow room, dating from the fifteenth-century
rebuilding. The lord's apartments were in this tower, which was originally two storeys high,

but was heightened to three by Humphrey Stafford. The quality of the decorated windows, the fireplaces and the carved corbels on the upper floor indicate sophistication and comfort.

Newport Castle had an active life of only around 200 years, and it was only actually occupied by its lord during very little of this time. For a brief time at the beginning of the sixteenth century, Jasper Tudor, Henry VIIIs uncle, lived here. It played no significant part in national politics and its main function was the day-to-day administration of the Lordship of Wentloog.

Medieval Ship

Much more substantial, and due to be reassembled in three dimensions, are the remains of the Newport Medieval Ship, which 'came to Newport and never left'. The ship is regrettably not in situ, but is being resurrected on an industrial estate in the city.

In the summer of 2002, on the muddy banks of the River Usk, the remains of a fifteenth-century ship were found. Recovered, they now form a fascinating project to reveal the life and times of medieval Newport and her trading partners along the Atlantic seaboard.

The author came to witness a BBC news programme about the archaeological rescue of the ship's timbers and was interviewed as part of the programme.

Did You Know?

The substantial remains of a medieval ship were discovered on the banks of the River Usk. In 2002, when excavating for the orchestra pit of the new Riverfront Theatre, contractors found the vessel. Of unknown name, this mighty ship came to Newport sometime after the spring of 1468 for repairs and was berthed in a side inlet or 'pill' at high water to allow access to her lower hull. At some later point, the props on the starboard side failed and she toppled over – never to be recovered.

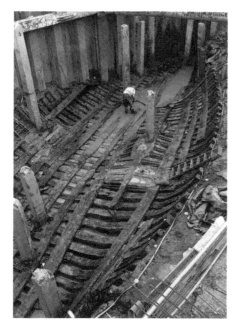

Excavating the medieval ship.
(Courtesy of Newport City Council)

'The Final Resting Place'. (Courtesy of Friends of Newport Ship)

As they are returned from York, the timbers are held in the climate-controlled store at the Medieval Ship Centre. Here, Friends of the Newport Ship are able to welcome the public, explain the project and the conservation processes, tell their stories and explain their vision of the future.

The ship was a large, three-masted armed merchant vessel, built in the Basque Country after 1449. She is the most complete fifteenth-century European ship ever recovered. Clinker-built, almost entirely of oak, but with a beech keel, she was much repaired and probably refitted during her eighteen years of service. She was likely engaged in the Iberian wine trade as well as carrying general cargoes, and would have carried a crew of thirty to fifty, depending on cargo. The ship was dismantled at Newport in 1468–1470 after coming to grief while under further repair. She was cleaned, recorded and conserved between 2003 and 2016, and has been physically modelled in 1/10th scale as a guide to future reconstruction. She continues to yield a wealth of evidence about crew and cargoes and medieval life, time and trade, as well as providing a 'magnificent and inspiring' heritage icon for the people of Wales.

Aristocratic Newport
Tredegar House and the Morgans
Thomas Morgan of Plas Machen inherited Tredegar House in 1653. It was he who probably started to rebuild Tredegar House, but, as he died in 1666, it is likely that his son Sir William Morgan built most of the new house. The work was completed in 1672 and the new Tredegar House was – and still is – a very grand house with state rooms, fine bedrooms, a large park and all the requirements needed by a rich family of landed gentry. The Morgans continued to accumulate land to enjoy their lifestyle and inherited wealth from relatives such as John Morgan of Ruperra Castle, who had become rich from the shipping trade.

Did You Know?

Evan Morgan was the last of the Morgan family to live at Tredegar House. He inherited the title and the estate in 1934, 'but continued to live a lavishly eccentric aristocratic life in London'. He and his wife Lois often spent the weekends at Tredegar House, where they would entertain house guests, including the occultist Aleister Crowley. The parties were not only opulent with five-course dinners, they were characterised by one of Evan's greatest eccentricities: his collection of animals. Although he made the stables a menagerie – with kangaroos and monkeys, a baboon called Bimbo, and an alligator – the white Arctic owl and macaw had the run of the house. His pet black widow spider completed the ensemble.

Jane Morgan, who was married to Sir Charles Gould, a successful lawyer and judge, inherited the estate in 1792. On gaining the Tredegar Inheritance, Sir Charles was granted the name and arms of Morgan and given a baronetcy. He then began developing the commercial and industrial potential of the Tredegar estates. He took advantage of coalmining and ironworking in South Wales and he invested in the construction of the Monmouthshire Canal and the Brecknock and Abergavenny Canal. He also owned land where the Sirhowy–Newport tram road crossed through his park. The tramway had been authorised by an Act of Parliament in 1802 and completed a few years later, becoming known as the Golden Mile because of the profits he made from the tolls on horse-pulled trucks crossing his land. He charged 'one halfpenny for every ton of coal or stone, one penny a ton for iron and two pence a ton for general merchandise'.

The buccaneer Sir Henry Morgan is believed to have been one relative of the Morgans of Tredegar House. As a young man, he went to sea and rose to the rank of admiral. When he became Lieutenant-Governor of Jamaica, he was famous (or notorious) for attacks on the Spanish in the Caribbean, including the sacking of Portobelo near Panama. He died in Jamaica in 1684 but there is no evidence that he ever visited his kinsmen at Tredegar House.

Probably the finest building in Newport, it was rescued by Newport Council and is now managed by the National Trust. Visitors are invited to:

Evan Morgan and H. G. Wells.
(Photographer unknown)

Discover the sumptuous interior of a home designed to impress and entertain guests.
From intricate carvings to a gilded room, the walls alone exude flamboyance
Explore the impressive stable block; admire the Edney gates and the striking architecture.
Uncover the secrets of the servants and wonder at the Great Kitchen, the largest, loftiest and
most important room below stairs. Enjoy a relaxing walk around the lake and extensive grounds.

The National Trust has also produced a handy guide to 'meeting the Morgan's, featuring six members of the family from 1560–1949, with tales of ill-fated marriages, riotous parties, dark arts, war, heroism and animal menageries ... the Morgan's certainly ran no ordinary household'!

Victorian Newport
Newport Rising – The Chartists
The Newport Rising was the last large-scale armed rebellion against authority in Great Britain and one of the largest civil massacres committed by the British government in the nineteenth century, when, on 4 November 1839, almost 10,000 Chartist sympathisers, led by John Frost, marched on the town of Newport, Monmouthshire. The men, including many coal miners, most with home-made arms, were intent on liberating fellow Chartists who were reported to have been taken prisoners in the town's Westgate Hotel. Around twenty-two demonstrators were killed when troops opened fire on them. The leaders of the rebellion were convicted of high treason and sentenced to a traitor's death. The sentence was later commuted to transportation for life.

The origins of Chartism in Wales can be traced to the foundation in the autumn of 1836 of Carmarthen Working Men's Association.

Among the factors that precipitated the rising were the House of Commons' rejections of the first Chartist petition – the People's Charter of 1838 – on 12 July 1839 and the conviction of the Chartist Henry Vincent for unlawful assembly and conspiracy on 2 August. Some kind of rising had been in preparation for a few months and the march had been gathering momentum over the course of the whole weekend, as John Frost and his associates led the protesters down from the industrialised valley towns to the north of Newport. Some of the miners who joined the march had armed themselves with home-made pikes, bludgeons and firearms.

The march was headed by Frost leading a column into Newport from the west, Zephaniah Williams leading a column from Blackwood to the north-west and William Jones leading a column from Pontypool to the north.

The exact rationale for the confrontation remains unclear, although it may have its origins in Frost's ambivalence towards the more violent attitudes of some Chartists and the personal animus he bore towards some of the Newport establishment. The Chartist movement in south-east Wales was chaotic in this period and the feelings of the workers were running extremely high.

Events Leading up to the Rising
Heavy rainfall delayed the marchers and there were delays in the planned meeting of each contingent at the Welsh Oak in Rogerstone. In fact, Jones and his men from Pontypool never arrived, delaying the final march into Newport into the daylight hours and thus contributing to its defeat. As the march progressed down the valleys on the Sunday morning, an entire chapel congregation was pressed into swelling the ranks of the marchers.

After spending Sunday nights mostly out of doors in the rain, the commitment of many of the marchers was lukewarm. Many had been ambivalent to the Chartist cause in the first place, more concerned with the immediate problems of their own employment conditions. Thus, many marchers did not participate in the final assault on Newport and simply waited in the outskirts of the town.

Rumours of a possible Chartist rising and previous violence elsewhere, following the earlier arrest of Chartist leader Henry Vincent and his imprisonment at the gaol in Monmouth, meant that the authorities had suspected there might be a riot. The sheer scale of the rising, however, was not fully appreciated until 3 November – the day before the riot. The authorities then quickly started to prepare. The mayor of Newport, Thomas Phillips, had sworn in 500 special constables and asked for more troops to be sent. There were around sixty soldiers stationed in Newport already and he gathered thirty-two soldiers of the 45th (Nottinghamshire) Regiment of Foot in the Westgate Hotel. Where the Chartist prisoners were held.

Climax of the Rising

The Chartists were convinced that some of their fellows had been imprisoned at the Westgate Hotel. Filing quickly down the steep Stow Hill, the Chartists arrived at the small square in front of the hotel at around 9.30 a.m. The flashpoint came when the crowd demanded the release of the imprisoned Chartists. A brief, violent and bloody battle ensued. Shots were fired by both sides; contemporary accounts indicate that the Chartists attacked first. But the soldiers defending the hotel, despite being greatly outnumbered by the large and very angry crowd, had vastly superior firepower, training and discipline, all of which soon broke the crowd. The Chartists did manage to enter the building temporarily, but were forced to retreat in disarray. After a fiercely fought battle, lasting approximately half an hour, between ten and twenty-four of their number (a fair estimate is twenty-two) had been killed by the troops and upwards of fifty had been wounded.

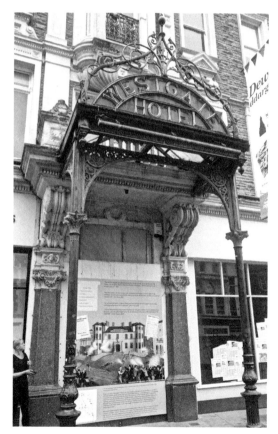

Westgate Hotel.

Chartist memorial at St Woolos Cathedral.

Did You Know?

The phrase 'Reading the Riot Act' is derived from the Riot Act of 1714, an Act of Parliament that authorised local authorities to declare any group of twelve or more people to be unlawfully assembled and thus have to disperse or face punitive action. The full title was 'An Act for Preventing Tumults and Riotous Assemblies and for the More Speedy and Effectual Punishing of the Rioters'.

It was in force from 1715–1967 and was read out by the mayor of Newport when confronted by the Chartists in November 1839

Among the defenders of the hotel, Mayor Thomas Phillips was badly wounded and one soldier was seriously hurt, along with two of the special constables. As the Chartists fled they abandoned many of their weapons, a selection of which can still be seen in Newport Museum.

Some of the Chartist dead were buried in St Woolos Parish Church (now Newport Cathedral) in the town where there is still a plaque to their memory. Some of the bullet holes from the skirmish remained in the masonry of the hotel entrance porch until well into modern times.

Aftermath

In the aftermath, 200 or more Chartists were arrested for being involved and twenty-one were charged with high treason. All three main leaders of the march – John Frost, Zephaniah Williams and William Jones – were found guilty on the charge of high treason and were sentenced at the Shire Hall in Monmouth to be hanged, drawn and quartered. They were to be the last people to be sentenced to this punishment in England and Wales.

After a nationwide petitioning campaign and, extraordinarily, direct lobbying of the Home Secretary by the Lord Chief Justice, the government eventually commuted the sentences of each to transportation for life. Other Chartists involved in some way included James Stephens, John Lovell, John Rees and William Price and according to some accounts Allan Pinkerton.

Testimonies exist from contemporaries, such as the Yorkshire Chartist Ben Wilson, that a successful rising at Newport was to have been the signal for a national uprising. Older histories suggested that Chartism slipped into a period of internal division after Newport. In fact, the movement was remarkably buoyant (and remained so until late 1842). Initially, while the majority of Chartists, under the leadership of Feargus O'Connor, concentrated on

petitioning for Frost, Williams and Jones to be pardoned, significant minorities in Sheffield, East End of London and Bradford, planned their own risings in response. Samuel Holberry led an aborted rising in Sheffield on 12 January; police action thwarted a major disturbance in the East End of London on 14 January; and on 26 January a few hundred Bradford Chartists staged a rising in the hope of precipitating a domino effect across the country. After this, Chartism turned to a process of internal renewal and more systematic organisation, but the transported and imprisoned Newport Chartists were regarded as heroes and martyrs among workers.

Meanwhile, the Establishment and middle classes became convinced that the rising meant all Chartists were dangerously violent. Newport Mayor Thomas Phillips was proclaimed a national hero for his part in crushing the rising and was knighted by Queen Victoria barely six weeks later.

Frost himself was eventually given an unconditional pardon in 1856 and allowed to return to Britain, receiving a triumphant welcome in Newport. But he never lived in Newport again, settling instead in Stapleton near Bristol, where he continued to publish articles advocating reform until his death, aged ninety-three, in 1877.

Commemoration

Interest in the Newport Rising was kept alive through occasional articles in the *Monmouthshire Merlin* and *South Wales Argus*. In 1939, to commemorate the centenary of the rising, Newport Borough Council erected a plaque on the Post Office building near the birthplace of John Frost. In the 1960s, redevelopment of Newport led to the creation of a central square, which was named John Frost Square. The Chartist mural was situated in an underpass leading to the square. Newport Museum had a display relating to the uprising, which included home-made weapons. In 1991, three statues commemorating the uprising – *Union*, *Prudence* and *Energy* by Christopher Kelly – were installed on Commercial Street at the front of the Westgate Hotel. In 2015, it was announced that Duffryn High School was to be renamed John Frost School. An annual Chartist Convention is held in the city.

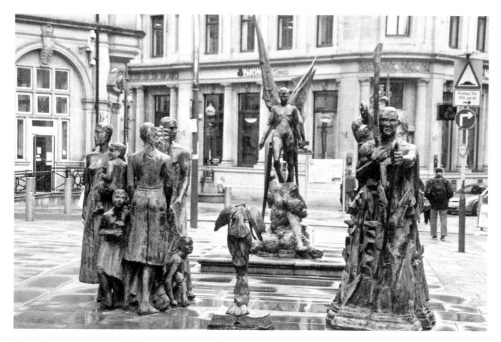

Chartists statues outside the Westgate Hotel.

Newport's modern retail and leisure scheme Friars Walk, incorporates two original and striking artworks, which pay tribute to the city's history. Commissioned by developers Queensberry Real Estate and created by celebrated artist Sebastien Boyesen, they are a commemoration of the Chartists' fight for democracy in the nineteenth century.

A large fret-formed piece of steel intricately cut to include a Celtic pattern and moving lines of poetry by Gilliam Clarke, the previous National Poet of Wales, is situated on the Kingsway side of the centre so it is visible to passers-by. Nearby, the six points of the People's Charter are engraved in the public steps that link the new John Frost Square to Usk Plaza. John Frost was one of the leaders of the Newport Uprising, who were arrested and eventually deported to Australia because of their involvement. The movement was ultimately successful and five of the six points of their charter form the basis of democracy in the UK today.

Although the most significant event in Newport history may not be a secret, many of the locations mentioned are less well known. The 'Walk in the Footsteps of the Chartists' leaflet produced by Our Chartist Heritage, encourages everyone to seek out these secret places to learn and understand more about the Chartists.

While it can be said that the Chartists and the development of the docks represent the most significant elements of Victorian Newport, there is much to be discovered elsewhere in the city. For example, the formation of the Poor Law Union in 1836 and erection of the workhouse are contemporary with and connected to the Chartist uprising. The workhouse was built in 1837–38 to the south of Stow Hill on land donated by Sir Charles Morgan. The Poor Law commissioners authorised expenditure of £4,000 on the building to house 200 inmates. Its layout used the popular cruciform plan up until the entrance at the north, behind which four wings radiated from a central supervisory hub. By 1868–69 the workhouse was enlarged to a capacity of £500 with notable new additions of a hospital, infirmary and chapel. The surviving buildings now form part of St Woolos Hospital.

Former Newport Workhouse, now St Woolos Hospital.

Dos Nail Works

In the same decade, James Cordes, a wealthy industrialist established the Dos nail works on Factory Road, near the Mill Street gasworks. The factory was called the Dos works, meaning 'two' in Spanish as the family were of Spanish and American descent. The works employed more than 1,000 people, being the largest nail factory in the country. It was reported that Mr Cordes was well aware of his own wealth and the poverty surrounding him. He made an effort to help his workers bring up their children and building a school and insisting that the children spent part of each day learning from the Bible. His achievements are recalled in a blue plaque sponsored by Newport Civic Society.

By the middle of the nineteenth century the railway and tram road system of Newport and Monmouthshire was quite extensive, but isolated from the rest of Great Britain. Not until 18 June 1850 did a main line reach the town, when the 75 miles of the South Wales Railway were opened from Chepstow to Swansea. This was laid out by I. K. Brunel and built to the Great Western broad gauge of 7 feet 0.25 inches. A branch, north-eastwards from Newport to Monmouth, was authorised but not constructed, although there is evidence that earthworks were started near Caerleon. Brunel's bridge over the River Wye at Chepstow was opened on 19 July 1852, thus completing a through line of broad-gauge railway from Paddington through Gloucester to Newport and Swansea.

It is reported that Isambard Kingdom Brunel drove the first train across the River Usk at high speed and into Newport High Street station, which consisted of two platforms with three tracks between them and no overbridge. The tracks converged into two just east of the station, where there was a level crossing.

Brunel's train crossed the river on a newly built railway bridge, the second across the Usk after the first built of timber had burnt down in 1848. To conclude, the South Wales Railway had been built to Brunel's 'broad' gauge. By 1873 its tracks were converted to Britain's standard gauge, linking Newport directly and conveniently with the rest of Britain.

2. Religious Newport

St Woolos Cathedral

Perhaps because of the unusual dedication to Saint Gwynllyw (Woolos is an English or Anglo-Norman corruption of his name), locals and visitors alike can be heard to exclaim, 'I did not know that Newport has a cathedral'. It certainly does, and the Cathedral Church of St Woolos is built on top of the ridge that dominates the city. The church lies parallel to the line of the ridge and from its east end, the ground falls steeply with houses and cottages in tiers down to the commercial centre, the River Usk and the docks beyond. Formerly, that commercial heart followed the gentler slope from the castle – the Casnewydd of the town's Welsh name – to St Woolos Church in the hamlet of Stow.

Legend has it that Gwynllyw founded the cathedral around AD 500. Little is known about this saint but, according to medieval tradition, he was a feared warlord and raider (this equates with pirate and slave traders) who knew King Arthur. He was married to Gwladys, daughter of Brychan (or Brecon), and it was through her piety and that of their son Cadoc that Gwynllyw converted to Christianity. Chronicles tell how Gwynllyw was told in a dream to search for a white ox with a black spot on its forehead and to build a church there as an act of penitence. He died in the arms of his son on 29 March, the day on which his festival continues to be observed.

The mud and wattle structure subsequently erected became his grave, the foundation for a succession of churches built on the site at the top of Stow Hill. The extension, Galilee Chapel, now called St Mary's Chapel, still has evidence of its early Celtic foundation, although the main construction is Norman.

In the medieval period, the church was plundered by Irish pirates, Danes and the English. After the Norman Conquest, the army of William Rufus (William II) is said to have camped around the church in 1093, knelt at the altar and made offerings.

Around 1080 the Normans erected their archway, together with the nave and south aisle. The Norman arch is one of the glories of the cathedral. The tapering pillars are reputed to have been brought from Caerleon. They are Roman and have Corinthian (leafy) capitals, which seems to have been damaged before being sculpted in the eleventh century. The symbolism of these carvings reminds the author of Noah's flood, again a metaphor for escaping the flood plain of the Usk at Caerleon to the sanctuary of the church high above the river. In 1093, the king granted the church to the monastery of St Peter's in Gloucester, a relationship that continued after the Reformation when the abbot was replaced in Gloucester by a bishop. This connection only ceased in 1882.

The tower was built in the fifteenth century, at the same time as the north aisle. Near the top is a niche containing a damaged statue said to be that of Jasper Tudor, who was uncle of Henry VII and Governor of Newport from 1485–95.

The Reformation in the sixteenth century brought little change. By 1640 Puritanism has taken a firm hold in the area, and by the beginning of the nineteenth century the church was said to resemble a Nonconformist chapel. By mid-century the Victorians stepped in amid the Gothic revival, and from 1853 a full restoration programme was underway. This continued well into the twentieth century. A detailed architectural history is given in the highly recommended illustrated guidebook.

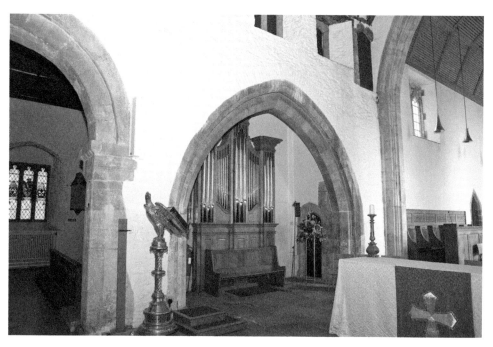

Above: Norman arches.

Below left: Cathedral tower.

Below right: East window.

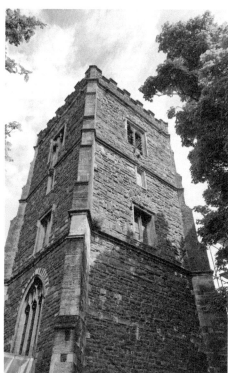

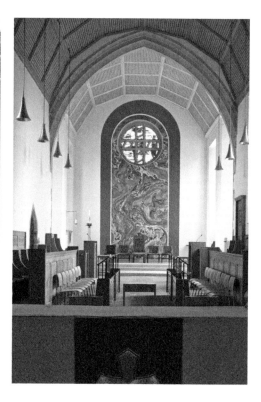

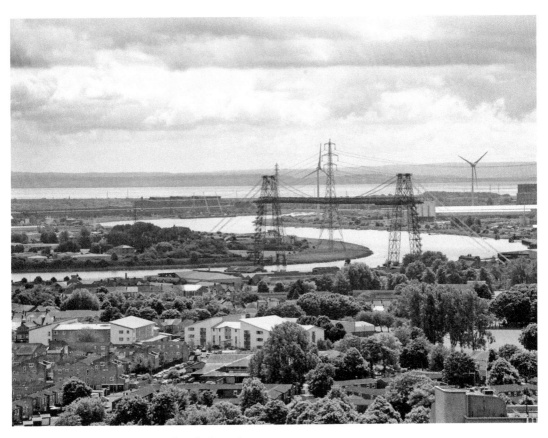

Panorama – Transporter Bridge, docks and estuary.

Up to the twentieth century, St Woolos had been a parish church. In 1921, following disestablishment, the new diocese of Monmouth was created. In 1949, St Woolos became its cathedral. There followed extensive expansion to reflect its new status, including the building of a new chancel with a magnificent mural and stained-glass east window in 1960–63, designed by John Piper. John Piper was renowned for the Baptistry Window at Coventry Cathedral. Finally, in 1990–91, a new hall was built, creating 1,500 years of Christian worship, art and architecture.

The bell tower now houses a peel of thirteen bells (the largest and the loudest in Wales) and announces the main Sunday morning worship every week, resounding from its hilltop position over the city of Newport. Thanks to the generosity of the dean and chapter and the assistance of the cathedral administrator, the author and photographer were given unrivalled and unrestricted access to the roof of the tower. Panoramic views show the House of Octavius Morgan and Belle Vue Park, the Transporter Bridge, River Usk, Newport Docks and the Severn Estuary.

St Woolos Cemetery

This is the main and most interesting cemetery in Newport, situated a mile west of the cathedral known by the same name. The original cemetery lodge is now used by Newport City Council as the Cemetery Office from where the superintendent and clerk can direct visitors to points of interest, such as the spot the Cybermen were filmed during the production of an episode of *Doctor Who*.

One of the most poignant memorials is dedicated to the Newport Docks Disaster of 1909, where thirty-nine men were killed when the retaining wall in the excavation to extend Alexandra Docks collapsed, trapping the men in mud, water and heavy debris. The heroic endeavours of Tom 'Toya' Lewis are recounted in the chapter on Newport heroes. The memorial

Did You Know?

St Woolos Cemetery, the main cemetery in the city, was the first municipally constructed cemetery in England and Wales. It contains four chapels, notable memorials and ornate graves. It shows its Victorian creation in its original design of seven distinct burial areas, i.e. six socio-economic class divisions plus a large area for pauper burials. Religious distinctions are evident in the Anglican chapel, Nonconformist chapel, Roman Catholic chapel, synagogue and Jewish cemetery. All of these buildings are unused, although there is present-day provision for Muslim burials.

itself is a coarse finished granite obelisk with three imitation brass plaques commemorating the names of the men killed.

There is a war memorial commemorating local men who died in the First World War, dedicated to the 197 soldiers and sailors buried at St Woolos and Christchurch cemeteries. The Commonwealth War Graves Commission is responsible for a plot with 167 Commonwealth service personnel of the First World War and ninety-eight of the Second World War, together with ten foreign national graves. To corrupt the words of Rupert Brooke, there's some corner of a foreign field that is forever Portugal and the Netherlands.

The keen graveyard explorer can also seek out three headstones, each with a story to tell. The first of these belong to John Byrne from the 68th (Durham) Light Infantry (DLI).

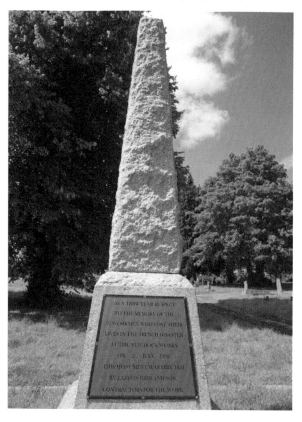

Memorial for the Newport Docks Disaster.

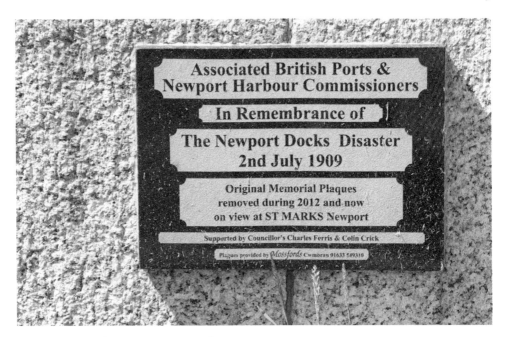

Above: In Remembrance – Newport Docks Disaster.

Below left: Portuguese headstone.

Below right: Netherlands headstone.

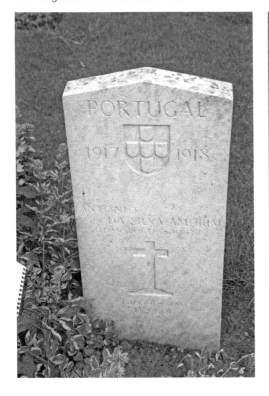

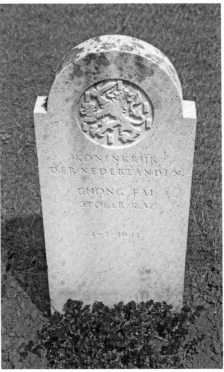

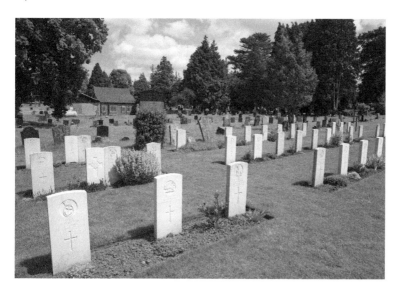

Commonwealth War Graves Commission section.

In November 1853, Byrne had been sent to prison for an unknown offence. In August 1854, the 68th set sail for the Crimea and Private Byrne was released from his cell to join his regiment. On 5 November 1854, the Battle of Inkerman was fought just outside the Russian naval base of Sebastopol. Around 200 men of the 68th DLI drove back three Russian battalions. Then the 68th was attacked. With their ammunition gone, the soldiers were forced to retreat and leave their wounded behind. As they fell back and the Russians advanced firing, Private Byrne (aged twenty-two) turned and ran towards the enemy to rescue a badly wounded comrade, Anthony Harman. He was awarded the Victoria Cross, the highest award for gallantry.

On 11 May 1855, Private Byrne was again involved in a fierce fight when a large Russian force left Sebastopol and attacked British trenches held by two companies of the 68th. He struggled in the dark and driving rain with a Russian soldier on the parapet of the trench, before bayoneting him and capturing his musket, which reports described as 'an example of bravery the consequence of which was the speedy repulse of the sortie'.

In 1863 Private Byrne sailed with is regiment for New Zealand, where the Maoris were fighting to halt the spread of the British settlements on North Island. At the Battle of Te Ranga, Private Byrne, now a corporal, was the first man of his company to jump down into the rifle pits, where he bayoneted a Maori soldier. The Maori grabbed his rifle with one hand, held it firm and, despite the bayonet still sticking in him, tried to cut Private Byrne down with a war axe. The struggle only ended when Sergeant John Murray killed the Maori. For his actions during this battle, Private Byrne was awarded the DCM. In 1866, he was promoted to sergeant and took his discharge in 1872 at the age of forty, after twenty-one years' service.

He later he joined the 2nd North Durham Militia in Durham as a colour sergeant, but was discharged within a few months for 'insubordination and highly improper conduct'. He does not reappear in the records until 1878, when he began work as a labourer with the Ordnance Survey in Wales.

On 10 July 1879 at Newport in Gwent, John Byrne accused fellow workman John Watts of insulting the Victoria Cross. In the argument that followed, he shot Watts, who was around nineteen years old, with a small revolver, hitting him in the shoulder. When the police went around to his lodgings at No. 7 Crown Street, Maindee, John Byrne VC DCM placed the barrel of the revolver in his mouth and pulled the trigger. He was forty-six years old.

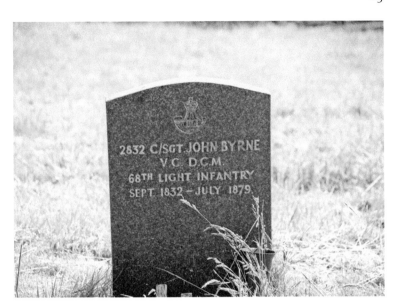

John Byrne VC.

At the inquest held on 12 July, the coroner was told that Byrne had arrived in Bristol in October 1878, claiming that he had lost all his possessions in a fire in Cork. Byrne's landlady, Mrs Eliza Morgan, then stated that while her lodger enjoyed a pint of beer she had never seen him under the influence of drink. Unsurprisingly, the contemporary local newspaper carried full accounts of the incident and of the subsequent inquest. There the jury, 'after a short consultation', returned a verdict that the deceased, John Byrne, committed suicide while in an unsound state of mind. He was buried in an unmarked pauper's grave until 4 November 1985, when the then Major General Peter de la Billiere, who originally served with the DLI, unveiled an inscribed headstone to John Byrne, recognising the first soldier of the regiment to be awarded the Victoria Cross.

This remarkable story has not yet concluded as the Museum of London has reported the find of a Victoria Cross medal from the Thames foreshore. Intriguingly, the medal is dated 5 November 1854 but the recipient's name engraved on the suspender bar is missing. There were sixteen Victoria Crosses awarded to British troops after the Battle of Inkerman in the Crimea. Of these, only two are unaccounted for: those won by John Byrne of 68th Light Infantry and Private John McDermond of 47th (Lancashire) Regiment of Foot. It is possible that the missing medal belonged to John Byrne but there is insufficient evidence to prove it. However, there is no doubting the bravery of a man from Ireland, who died and is buried in Newport. He deserved to be remembered more widely.

The second noteworthy headstone belongs to John Jeremiah Lyons. The society explains that the Anglo-Zulu War was one of the extraordinary periods of Victorian history. Many people are aware of the Battle of Rorke's Drift – made famous by the film *Zulu*, starring Stanley Baker and Michael Caine. From contemporary war diaries and medical reports, we know that Corporal John Lyons was struck in the neck by a musket ball. 'Thus wounded, he encouraged his fellow Corporal, William Allen, before being dragged to safety and to the care of Surgeon Reynolds.' The skill of the surgeons saved Lyons' arm – and his life – and enabled him to return to England. Thirty-seven years later he was photographed 'still doing his duty' at the Recruiting Office, Newport, in 1916.

Thirdly, the family of Annie E. Brewer erected a headstone in memory of Nurse Annie E. Mistrick (née Brewer). The full story is contained in chapter 5, 'Newport Heroes'.

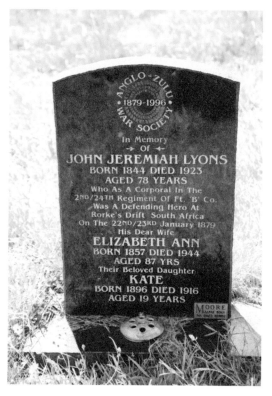

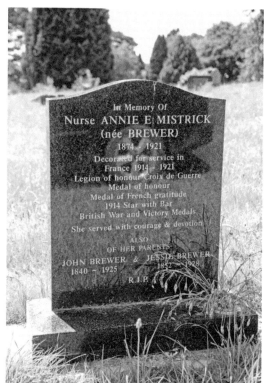

Above left: John Jeremiah Lyons.

Above right: Annie Brewer's headstone.

Below: HMS *Gibraltar* at Cashmore's, River Usk.

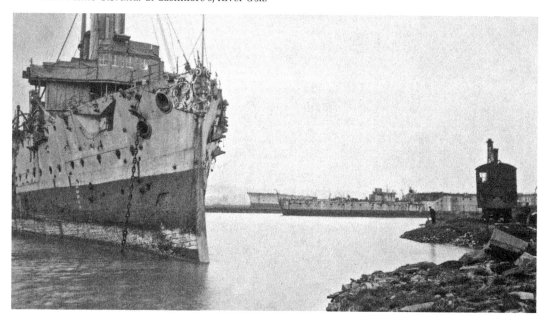

3. Maritime Newport

Canals

This chapter starts with the canal system linking Newport, a small trading town on the banks of the River Usk, with the Monmouthshire hinterland. These waterways were the stimulus for Newport's development into a large industrial and commercial city.

In 1792, an Act of Parliament authorised the construction of the Monmouthshire Canal. This consisted of a main line, 11 miles long, from Newport to Pontnewydd via Pontypool and a branch to Crumlin. It allowed coal and iron to be transported to Newport much more efficiently and was also used for lime, timber and farm produce.

Fourteen locks on the Crumlin branch at Rogerstone was part of a complex of locks, weirs and ponds, to enable boats to rise or descend some 358 feet. The Fourteen Locks Canal Heritage Centre opened in 1976, with facilities, displays and access to a vital section of the restored canal. The canal itself served the wharves on the River, which was subject to the second highest tidal range in the world, around 49 feet and to the Town Dock.

Did You Know?

Among the many industries on the banks of the River Usk were Cashmore's shipbreakers and iron merchants. Until 1976 the company was renowned for scrapping merchant and naval ships, as well as steam locomotives. Liners like the *Empress of France* MV *Reina del Pacifico* and RMS *Doric* met their end in Newport, as did the battleship HMS *Collingwood* and the cruiser HMS *Gibraltar*. There was always great public interest in the activities at Cashmore's; for example, a lunch and charity ball was held on the *Doric* in aid of the Royal Gwent Hospital and the ship was illuminated at night.

River Usk and Bridges

It can be argued that the city of Newport owes its existence and character to its river. The tidal reaches of the Usk have been used as a major shipping port for millennia, mostly because of its wide and deep mouth and good navigable access from the Severn Estuary, the Bristol Channel and thence to home waters and further overseas.

Newport 360, the city council's guide to 'The Places and People of Newport', echoes this sentiment.

Newport's lifeblood is the River Usk, which starts over 60 miles away in the Brecon Beacons and divides the city in two. Designated a Site of Special Scientific Interest, there are wildlife-rich habitats on its entire length. Along the riverbank from Caerleon to the Estuary are the sites of a Roman harbour, the modest remains of Newport Castle, the Riverfront Theatre and Arts Centre and numerous bridges.

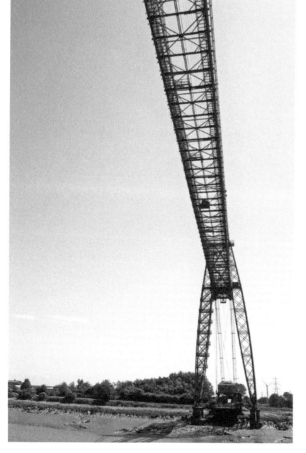

Above: City Bridge.

Left: Transporter Bridge.

Thanks to modern-day cycle routes (Route No. 88) and walkways, it is possible for both the dedicated and the casual visitor to experience the full glory of the riverscape. The key bridges are Town Bridge, Newport City footbridge, George Street Bridge (the UK's first cable-stayed bridge), City Bridge and the Transporter Bride – Grade I listed Notes provided by the City Council give a full account of the Transporter Bridge.

Newport is divided by a swiftly flowing tidal river, the Usk, which has proved to be a major obstacle. A permanent crossing was first recorded between 1158 and 1187, when a timber bridge was thought to have been constructed by the Normans soon after the castle was built. This and subsequent bridges constructed at the same spot remained the only river crossing for over 700 years. However, towards the end of the last century, rapid development of the east bank of the river was taking place and in 1896, J. Lysaght began to look for a suitable site to establish a steelworks. Seeking to attract employment to the area, the local authority realised that the original river bridge would not be able to cope with the anticipated increase in traffic and, in any case, was situated too far away from the areas being promoted for expansion.

Did You Know?

The Severn Estuary has the highest tidal range in Europe and the second highest in the world after the Bay of Fundy in Canada. For Newport, at the very highest tides, the sea level will rise by as much as 14.5 metres or 47 feet 7 inches over five hours and thirty minutes. Scientists at the University of the West of England have pioneered the 'sonification' of the extraordinary tidal rhythms of the Severn Estuary. On the water, seafarers have known the practical consequences of this remarkable natural phenomenon from Roman times to the present day. On land, too, it resulted in the design and construction of the Transporter Bridge.

A ferry crossing existed lower down the river but, because of the great tidal range of the river and the fact that several fatalities had occurred over the years, it was decided that a permanent crossing should be investigated. Several alternatives were suggested including a conventional bridge, a lifting bridge and a tunnel. The first of these was rejected as the topography of the surrounding area is flat and, in order to accommodate the high-masted ships using the river at the time and as the river has the second-highest tidal range in the world, the approach spans would have had to be unacceptably long. The lifting bridge was also rejected on the same grounds and the tunnel considered too expensive. The borough engineer at the time, Mr R. Haynes, had heard of the work of a French engineer named Ferdinand Arnodin who was designing a type of bridge called an 'Aerial Ferry' He proposed this type of construction to the councillors and, after a delegation visited Rouen to inspect a similar structure, this sort of bridge was adopted.

In 1900, parliamentary approval was obtained to build the bridge and work started in 1902. Haynes and Arnodin were appointed joint engineers and the contract was let to Alfred Thorne of Westminster. The bridge was completed at a cost of £98,000 and was opened on 12 September 1906 by Viscount Tredegar.

The bridge is, in effect, a suspended ferry, consisting of a horizontal railway track spanning between two sets of lattice towers. Running along the track is a traveller from which is suspended a platform, or gondola, which allows pedestrians and motor vehicles to be transported across the river. The bridge is electrically operated and the gondola is pulled across the river by means of a hauling cable, which is wound round a drum located in the motor house situated on the east bank of the river. In the past, up to eleven crew operated

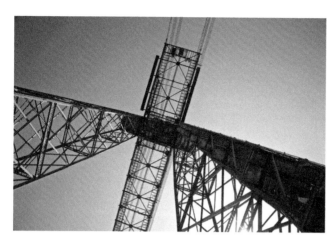

Transporter Bridge.

the bridge; today it is operated with a staff of seven – two sets of drivers and conductors, two maintenance men and a superintendent. The bridge operates to a timetable and makes a return journey every fifteen minutes, and can carry up to six cars or vans.

When opened, the bridge operated from dawn to dusk, but although tolls were charged the bridge was never able to pay its way and so by 1919 it was costing the council some £6,000 each year. Tolls were discontinued in 1946 and in 1964 a second river crossing, George Street Bridge, was opened just a short distance upstream. In 1979, the bridge celebrated its 75th anniversary and at this time was given Grade II-listed-building status, which was subsequently upgraded to Grade I in 1996. For some years it had been noted that deterioration of the structure was occurring and by 1985 strand breakages in some of the cables meant that the bridge was closed on safety grounds.

The owners at the time, Gwent County Council, obtained funds from CADW and also the European Architectural Heritage Fund, and in 1992 work commended on a major renovation programme. The first phase was the refurbishment of the towers and access ways, which was completed in 1993, while the second phase tackled the replacement of the main anchor and catenary cables during 1994. The final phase involved steelwork repairs, surface protection to the main boom, gondola and motor house. Other areas were also renovated, including the electrical and mechanical systems and floodlighting, which replaced the festoon lighting installed in the mid-1980s. The bridge was reopened in December 1995 by Clare Short MP, the Shadow Secretary of State for Transport. In April 1996, the ownership of the bridge was transferred to the new unitary authority, Newport County Borough Council.

There are admission charges for single and return gondola crossings, spanning 645 feet and access to the high-level walkway 177 feet high. Although a steep and challenging climb, there are spectacular views of the docks, River Usk, city of Newport and St Woolos Cathedral from the top. The bridge and volunteer-operated Visitor Centre are generally open from 10 a.m. to 4 p.m. Wednesday to Sunday, from April to September. A trip to the Transporter Bridge combines a unique landmark in Wales with insights into the history of the docks, Newport seafarers and the locality of Pill. It also forms part of the Wales Coastal Path.

Docks
Newport Docks are the least visible but most important element in the economy of Newport. Since they can only be visited on business, residents and visitors alike must climb to the top of the Transporter Bridge to appreciate them in full. Thanks to the generosity of Associated British Ports, Newport, this volume offers a view through the keyhole on some of the key events of the twentieth century at the docks.

Newport's development in the nineteenth century depended upon shipping. Coal, iron and other goods brought to Newport by the Monmouthshire Canal, which ran along the present Kingsway, could be easily transhipped to wharves fronting onto the river. By the 1830s there was a great need for a dock, especially as the riverbank was affected by the rise and fall of the tide.

The first dock in Pillgwenlly opened in October 1842, costing £200,000 to construct and covering 4.5 acres. It soon proved too small, and by March 1858 an extension of 11.5 acres was opened. As trade grew, the demand for more docks increased. The 1865 Act of Parliament authorised the setting up of Alexandra (Newport) Dock Co. to build an entirely new facility of 29 acres, close to the mouth of the River Usk. The Alexandra North Dock was completed in 1875, to be followed by the ambitious scheme for construction of Alexandra South Dock. The opening of South Lock in 1914 is described later in this chapter, together with the tragic episode of 1909, headlined as 'Disaster and Heroism'.

Disaster and Heroism, 1909

The photographic archive of Associated British Ports, Newport, gives an insight into the tragedy of 2 July 1909 that is commemorated by the public memorial at St Woolos Cemetery. Disaster struck that day when fifty-three men and boys were working in the outer wall trench, constructing the new South Dock. At around 5.20 p.m., a tremendous cracking sound was heard coming from the huge support timbers and within a few seconds they were catapulted into the air, before falling into the trench and onto the men 50 feet below.

When the cave-in was heard, railway engines all over the extension workings began to sound their whistles to summon help. It was reported that rescuers arrived within minutes and the operation to save those trapped was soon underway. The collapse was on a colossal scale and time was against the rescuers. The immediate danger was from the collapsed steam cranes, which still had their boilers lit.

At the same time the noise of the steam whistles alerted a certain Thomas Lewis, a fourteen-year-old newspaper boy who lived in Wallis Street. Tom's heroic endeavours are described in chapter 5, 'Newport Heroes'. He played a leading role in the rescue operations that continued throughout the night, illuminated by scores of acetylene flares and into the next day, Saturday 3 July. By noon, there was very little hope of anyone buried still being alive. By the afternoon, the tidal water began to seep over the excavated ground and enter

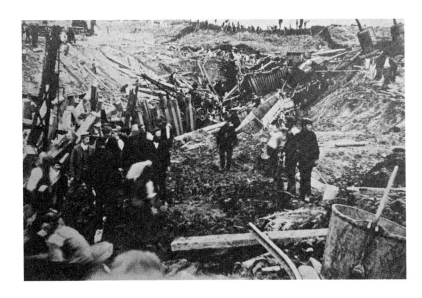

Disaster and Heroism.

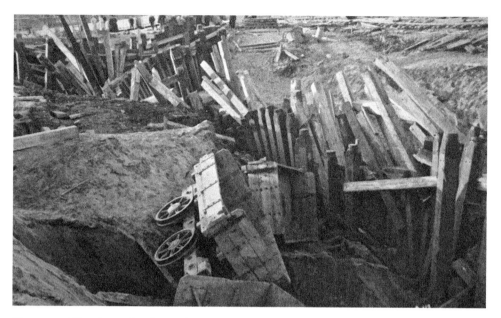

Disaster and Heroism – the aftermath.

the collapsed trench. The teams had managed to recover five bodies and rescue fifteen men, alive but injured. One of these later died from his injuries. The next day, Sunday 4 July, the collapsed trench was full of water and, with the approval of the coroner, work began to fill it in. On 8 July a funeral service was held on the site of the disaster, attended by over 2,000 mourners, families and friends, who had waited in vain. A year later in December 1910, while work was going on to sink blocks of stone near the area of the disaster, a further seventeen bodies were removed, leaving sixteen still buried beneath the South Dock.

Docks Dispute, 1910

Set against the backcloth of class conflict at the time of the Great Unrest, the dispute at Newport Docks is largely forgotten. It was highly significant in the development of industrial relations and policing. The preservation of group photographs of Monmouthshire, Cardiff City and Glamorganshire contingents of police forces has earned it a place in Welsh history.

A more dramatic picture of the role of Glamorganshire police in managing strikes was acted out in 'Stockers Copper', the BBC play for *Today* in 1972. The play was also featured in *World War One at Home: Whose Side Are You On*, which was about the Cornish clay strike of 1913 and was broadcast in 2014.

On Wednesday 18 May 1910, Houlder Brothers & Co. brought a Canadian steamer called *Indian Transport* into Newport Docks to load 5,000 tons of goods. It was the largest cargo at the port at that point and destined for South Africa. Before the steamer arrived, Houlder Brothers informed workers that, rather than the usual tonnage payment system, they would be paid a daily rate to load.

Unlike other major ports, stevedores in Newport were paid on a tonnage basis that gave regular gangs of dockers guaranteed work loading any cargo allocated to them. On being told of the change in the payment system, members of the Dockers Union refused to load the ship.

When the ship arrived in Newport, it was carrying the so-called free labourers from London. All 5,000 dock workers in Newport stopped work to crowd the vessel. A delegation of dockers entered the ship and informed the imported workers that they were scabbing and offered to pay for them to go back home; this offer was refused.

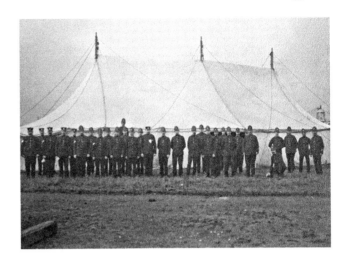

Monmouthshire Police.

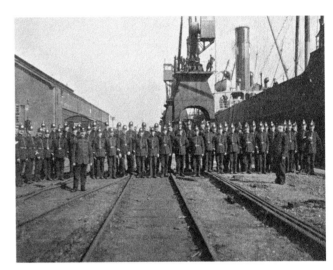

Cardiff City contingent of police.

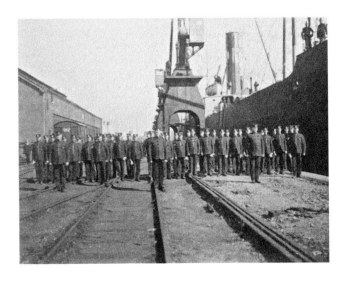

Glamorganshire contingent of police.

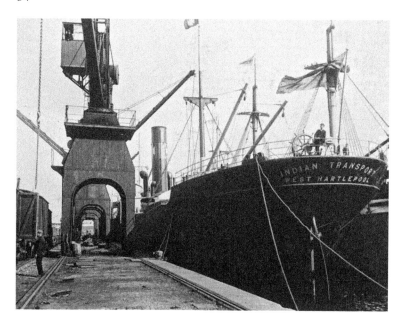

SS *Indian
Transport.*

When the blackleg labourers attempted to start work the crowd rushed the police line that had formed, threw the police into the dock and stopped work. The strike-breakers were escorted by the massed ranks of dockers under the union banner to Newport train station, where their fares were paid and they returned to London.

Work did not resume on the docks the following day as all work had already been halted for Edward VII's funeral on the Friday. Over the weekend, the dispute was sent for arbitration, allowing work on other ships to resume. A rally was held in Cathays Park, Cardiff, which was attended by thousands of workers from both towns, coming by train, foot and in a mass bicycle ride of over eighty dockers.

The workers were able to secure the solidarity of dock labourers in other ports in the Bristol Channel. As far as most exporters in the Newport Board of Trade were concerned, the tonnage system suited them perfectly well. The main criticism of rushed work leading to minor damage was hardly relevant to the loading of coal. The dockers themselves had their own reasons for opposing day wages, which was a system workers in other industries were clamouring for. In the words of one member of the Newport branch of the Dockers Union from the *South Wales Argus* on 18 May 1910,

> The conditions of the dock workers at Newport are in no way ideal; they are capable of improvement. The tonnage system gives a greater security and regularity of employment than is obtainable under the day wage system. Under the tonnage system a man works a job from start to finish, but under the other system he is taken on from day to day and can only claim to be employed four or five hours, for which he received an average of 6d an hour... Judging by the effect of the day wage system on other ports the results will be disastrous for the workers and to households and to tradesmen, because it will diminish the purchasing power of the labouring classes. The men fully realise, from report and practical experience that the conditions under the day rate will be worse than the tonnage basis.

It was acknowledged by all sides that the only result of blacklegs coming into Newport Docks would be serious violence. A large number of police were imported into the town and soldiers

were held in reserve. Arbitration was agreed, somewhat contentiously. On the day work was set to resume the Shipping Federation informed the Home Office that Houlder Brothers would be bringing in un-unionised labour.

Newport's Watch Committee (in charge of policing) deciding it would be better to keep the peace than enforce the law, prevented a ship containing strike breakers from entering the dock:

> ...the Newport Dock labourers are prepared to load the Indian Transport, this Committee are not prepared to provide the additional police protection which would be necessary if labour is imported, until commanded to do so by the Home Office, and that any labourers proposing to come to Newport be warned that it is unsafe to do so in the existing circumstances.
>
> *South Wales Argus*, 25 May 1910

In a desire to avoid an explosive confrontation, the Home Office took responsibility for the local authority's actions and informed Houlder Brothers they would be held responsible for the 'grave consequences' of importing scab labour. In effect, the Newport dockers had intimidated the government into backing them.

Houlder Brothers responded by demanding compensation from the local authority, as they were entitled to the protection of the state. The expensive consequences of this successful claim confirmed the legal right of employers to bring in strike breakers.

Opening of South Lock

Just weeks before the outbreak of the First World War, there took place a most peaceful and commercial event – the official opening of the new South Lock. This was the entrance from the Bristol Channel and not the River Usk. Work had started in 1906 and completed in 1914. On 14 July that year it was inaugurated by HRH Prince Arthur of Connaught, son of King George V. The first vessel into the South lock was the steam yacht *Liberty*, owned by Lord Tredegar. It broke a ribbon placed across the lock entrance.

The centenary of this event is commemorated by the mosaic made by sculptural artist Stephanie Roberts, situated outside the Mission to Seafarers.

The lock had a total length of 1,000 feet and width of 100 feet, being divided by watertight gates into two compartments of 600 and 400 feet, respectively. It was a sign of the future of world trade that one month later, on 15 August 1914, the Panama Canal was open to shipping with locks 110 feet wide.

Steam Yacht
Liberty
courtesy of the
roll of honour.

Mosaic by Stephanie Roberts.

First World War

Early on 4 August 1914, one of the first actions of the First World War took place in Newport and the Severn Estuary. The German ship *Belgia* steamed towards Newport, its captain and crew unaware that they were now at war with Britain. The story is that the ship was spotted by the keeper of the West Usk Lighthouse as it anchored off Newport. When news arrived in Newport that war had broken out, Chief Constable Gower sent twelve of his men to capture the German vessel. Captain Cutliffe, the dock master, took the thirteen policemen armed with borrowed army rifles in a tugboat to the now enemy vessel. They boarded the ship with no opposition and escorted the crew back to Newport. As well as a cargo of flour, bullion and seventy-three German reservists, it also carried a consignment of zoo animals bound for Hamburg zoo; these included alligators, racoons, fighting bull frogs, rattle snakes and a number of exotic birds. The men became the first prisoners of war of the conflict; the menagerie ended up as part of an exhibition at Abergavenny Fair.

Did You Know?

An incident in Alexandra Docks in April 1915 nearly led to war with Italy. A torpedo accidentally discharged by a Royal Navy destroyer narrowly missed a neutral Italian steamer lying at one of the coal hoists. In one of the best traditions of wartime secrecy and deception, the guilty ship was deliberately misnamed in the subsequent House of Commons statement. The secret of who almost irreparably altered the course of the First World War remains undisclosed to this day

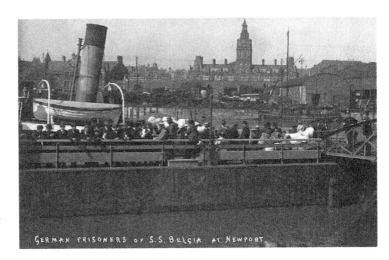

GERMAN PRISONERS OF S.S. BELGIA AT NEWPORT.

German liner *Belgia*.
(Photographer
unknown)

Discharge of Torpedo – Alexandra Dock, Newport

The briefest of references in the edition of *Hansard* for 6 May 1915 reveals an incident at the docks that might have changed the course of the First World War. Sir Richard Cooper asked,

> ...if, on the evening of 21st April, a party of ladies was taken over the torpedo destroyer 'Lawton' whilst lying in Alexandra Dock, Newport (Mon), and a torpedo was fired by one of the party across the dock, narrowly missing an Italian steamer and burying itself in the dock side; if so, what is the value of the damage done, including the value of the torpedo; and if it is within the regulations for parties of strangers to be shown over naval vessels during war time?

Dr McNamara, responding for the First Lord of the Admiralty said

> The facts are practically as stated, except that the accident was not caused by one of the party but that the firing of the torpedo was due to gross carelessness on the part of one of the crew, disciplinary measures for which are now being considered. The party consisted of four friends of a chief petty officer, two of them, I understand being employees in the docks. The estimated damage has not yet been ascertained, and I do not think it would be in the public interest to give the value of the torpedo. The regulations admit of the friends of the crew being shown round ships, during war, at the discretion of the commanding officer.

The Newport correspondent of the *Central News* wires showed commendable initiative in filing a fuller story that is quoted below:

> The accidental discharge of a torpedo in the Alexandra Docks at Newport to which the question addressed to the First lord of the Admiralty in the House of Commons has reference, caused considerable excitement in the vicinity of the docks.
>
> The circumstances, it appears, were very simple, but the consequences might have been serious.
>
> For some time past the Alexandra Docks have been used by the Admiralty as a base of torpedo-boat destroyers, and the officers have become exceedingly popular with the inhabitants of Newport.
>
> Many of the latter have from time to time been allowed to inspect the craft, the mechanism of which was explained.

Visitors Aboard

On the occasion referred to a gentleman, his niece, and another young lady were on board, and one of the gunners was explaining the working of the torpedo tubes and the discharging of the torpedoes.

The charge itself had been removed and placed to one side.

Meanwhile another gunner came along and, thinking the explanation had been concluded, replaced the charge, and went away.

On his return, the first gunner, unaware that the charge had been replaced, proceeded with his demonstration, and with the remark. 'This is how the torpedo is discharged.' pulled the lever.

Immediately there was a report, and, to the utter consternation of those on board, the torpedo left the tube and travelled at the usual depth under water, leaving a trail by which its course could be marked, righty across the dock, and making straight for a large Italian steamer lying at one of the coal hoists.

Italian Vessel's Escape

Everyone thought that the Italian steamer was doomed, but for some reason the course of the torpedo seemed to have been deflected, and instead of striking the steamer it crashed into the sloping wall of the dock some twenty feet astern of the vessel.

The explosion, however, threw the water a hundred feet into the air, drenching the men working on one of the hoists and many of those on the steamer, and considerably damaging the bank.

The feeling of relief of those on the destroyer when they saw that so little damage had been done, and that no personal injuries had been sustained, may be imagined.

The incident obviously had the potential to cause great embarrassment to the British government. More seriously, the Allies were in secret negotiations at this time with the Italian government, seeking to persuade the country to join the war against Germany and Austria-Hungary (the Central Powers). The sinking of a neutral Italian steamer with subsequent loss of life in a British port might have tipped the scales against the UK and French governments and induced Italy to side with Britain's enemies.

L-Class Destroyer. (Photographer unknown)

One of the undiscovered secrets is the name of the Royal Navy ship involved. There is no evidence of an HMS *Lawton* in the First World War. The supposition is that 'Lawton' is used as a collective reference to an 'L' or Laforey-class torpedo boat destroyer to avoid giving too much information to an enemy. On 1 May 1915, L-class destroyers from Harwich took part in the Battle of Noordhinder Bank off the Dutch coast.

UB-91

As if to mark the end of the First World War with some ceremony, the German submarine *UB-91* was put on display at Newport Docks after its surrender to Britain on 21 November 1918. The boat toured the ports of Cardiff, Newport, Swansea and Port Talbot and was towed to Pembroke Dock before being broken up in Briton Ferry in 1921. George V presented her deck gun to Chepstow in recognition of the bravery of William Charles Williams RNVR at Gallipoli

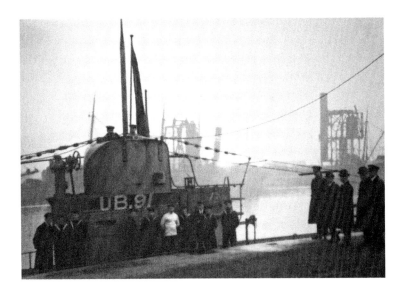

UB-91.

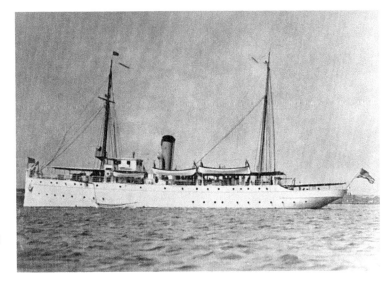

USCGC *Tampa*. (Courtesy of United States Coast Guard Service)

in 1915. It is believed that visitors to the vessel were charged 1s (5p) with the proceeds going to war charities.

The story of SM *UB-91* links Newport with Porthcawl, Lamphey (Pembrokeshire) and Arlington, Washington DC.

On 26 September 1918, the US Coast Guard cutter *Tampa* was escorting a convoy to Milford Haven, Wales. At 8.45 p.m. she was sunk without warning by UB-91. There were no survivors; 131 people officers, crew and passengers lost their lives. This was the greatest single loss incurred by the US Navy in the First World War as a result of known enemy action, and is commemorated at Arlington National Cemetery.

Two bodies were later washed up in Wales; one was identified as Seaman Fleury. The other was never identified. They were both buried with full military honours at Lamphey, Pembrokeshire; Seaman Fleury's body was later repatriated; the other still remains in Lamphey churchyard.

Newport Docks, 1920–39

The photographic archive of Associated British Ports, Newport, illustrates a wide range of peaceful activities in the period between the two world wars. In 1922, ownership of the docks passed to the Great Western Railway. Although the new owners were faced with an era of diminishing trade, this chapter gives an indication of Britain's export to its empire and to South America.

The 1920s started brightly with a royal visit. The Dock Company erected a 'canteen' on Middle Quay. The interior shot shows it 'smartly decorated for the visit of the Prince of Wales' on 7 June 1921. It looks like no expense was spared on this occasion. By way of contrast, the General Strike of 1926 gave a more humdrum scene of 'volunteers discharging potatoes'.

In 1930, the Town Dock was closed and attention was directed to maintaining the facilities of the Alexandra Docks. The loading of railway locomotives, carriages and wagons at the South Dock was zealously photographed. Fascinating examples include Anglo-Mexican Petroleum wagons for Brazil, the locomotives *Assam* and *Margaret* for South America and coaches for SG Railways. The final photograph of the 1930s shows sombre suited dignitaries greeting Prince Arthur of Connaught during his visit to Newport to mark the centenary of the Newport Harbour Commissioners. The setting looks markedly different from the junket prepared for the royal visit in 1921.

The Royal 'Canteen'.

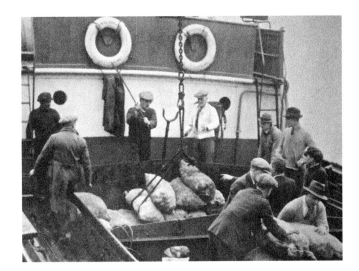

Volunteers unloading potatoes.

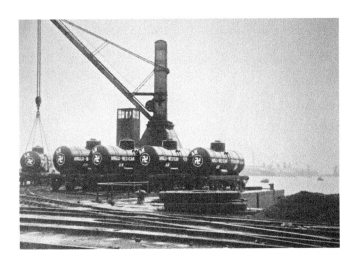

Anglo-Mexican petroleum wagons.

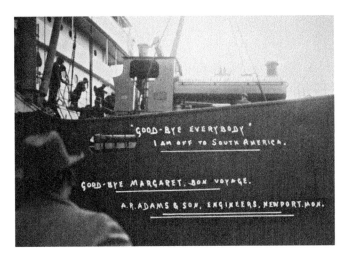

Margaret steam locomotive.

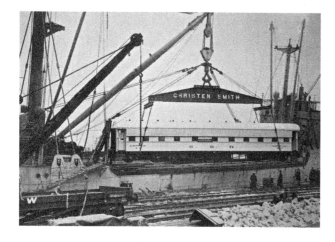

Railway coach.

Prince Arthur of Connaught.

The Second World War and Austerity

ABPs official record states that 'throughout the Second World War the general cargo equipment proved invaluable in handling vast quantities of war materials'. Unsurprisingly, there are few pictures of such activity with the exceptions of loading a steam locomotive for Iraq, unloading British tank and loading Landing Craft Mechanised/Mechanical (LCM) for the war in the Far East. The Canadian Hospital Ship *Lady Nelson* is pictured at Newport in November 1943.

After the war pre-fabricated houses – 'prefabs' – are being stacked like modern-day containers on the open deck of the French Aircraft Carrier *Dixmude*, formerly HMS *Biter*. British-made buses are being sent to Portugal. Later in the 1950s, there are photographs of the discharging of a cargo of iron ore from the River Afton and the loading of British Army on the *Framlington Court*.

Although it is not normally possible to see the docks themselves, visitors can take inspiration, comfort and refreshment from the nearby Waterloo Hotel, situated on Alexandra Road in the Pill area of the city. The Grade II-listed building was erected in 1904 and is regarded as a 'good example of a twentieth century public house, with a surviving interior of exceptional quality'.

For a brief period at the end of the nineteenth century and beginning of the twentieth, Newport Docks and South Lock were the largest in the world. Hundreds of dockworkers and

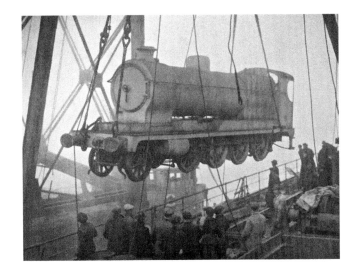

Locomotive for Iraq.

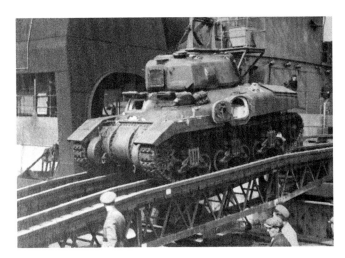

British tanks.

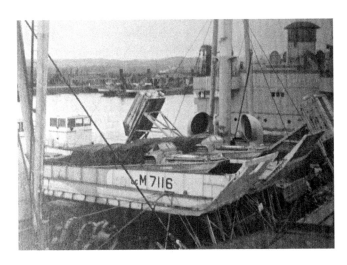

Loading landing craft.

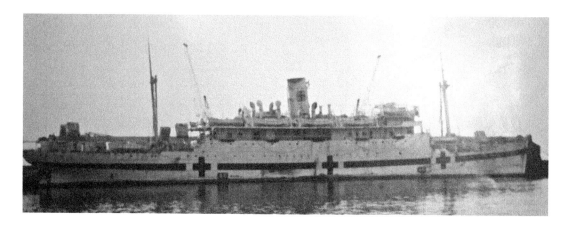

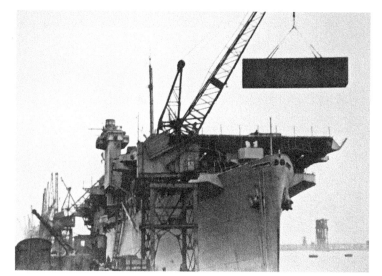

Abvoe: Canadian hospital ship *Lady Nelson*.

Left: French aircraft carrier *Dixmude*.

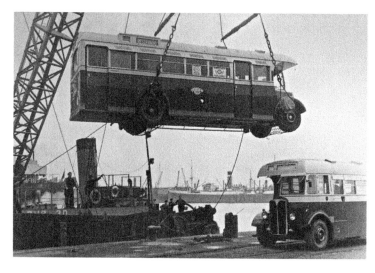

British buses for Portugal.

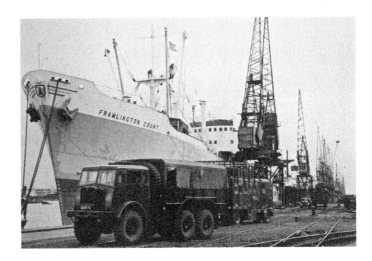

SS *Framlington Court.*

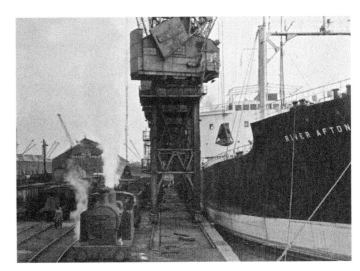

SS *River Afton.*

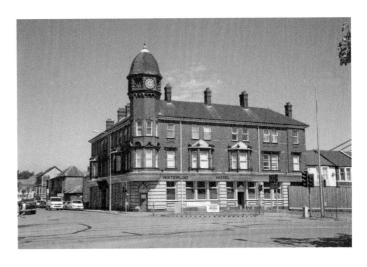

Waterloo Hotel.

traders drank in the Waterloo Hotel, which had a bar to match. The centenary of the opening of South Lock is commemorated at the Mission to Seafarers building at the entrance to the docks.

The Mission to Seafarers

The Mission is well located by the entrance to Newport Docks, close to the Transporter Bridge and the Wales Coast Path. The history of the Mission dates back to the early nineteenth century when a young Anglican clergyman, John Ashley, realised, while holidaying near the Bristol Channel, that the seafarers who manned the ships there had no one to minster to them. He decided to become their self-appointed chaplain. Today, the work of the Mission continues around the world working for justice and caring for all who earn their living at sea, regardless of gender, nationality, race, religion or rank.

The building is an unassuming brick-built single-storey construction dating to 1949. Except for the mosaic on the outside wall, the bland exterior belies the treasure trove within. Inside, there is the club area for seafarers and a remarkable chapel. The former displays the Honours Board from the 6th HMS *Devonshire*, an armoured cruiser of the 1904 vintage, which was broken up at Barrow-in-Furness in 1921. While the author identified the Lion Rampant and the ancient ship as the coat of arms of the county of Devon, and the five honours claimed by HMS *Devonshire* in various fleet and squadron actions in three different wars, he is unable to explain how the board reached Newport.

Also on display is a scale model of a sailing ship from the Royal Navy of Nelson's day. More significantly it was made by Edward (Ted) Dyer, a boatswain from Newport. As the accompanying plaque gives only an edited, truncated account of Edward Dyer's achievements, a fuller story appears in chapter 5, 'Newport Heroes'.

The chapel is notable for a number of features, including the nineteenth-century stained-glass window that came from the now-demolished Church of St Peters in Temple Street, Newport. Splendid also are the flags of local naval associations hanging on the walls. The chapel houses the Book of Remembrance and the Distinguished Service Medal (DSM) awarded to Ivor John Tilley. The full stories of Edward Dyer and Ivor John Tilley are deservedly key elements in chapter 5, 'Newport Heroes'.

HMS *Devonshire* honours board.

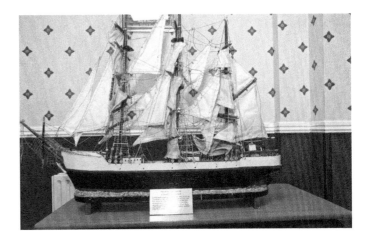

Model ship.

Mission chapel.

Book of remembrance.

4. Military Newport

This chapter is not intended to give a full description of all the wars involving Newport and Newportonians. The author has instead selected four instances that illustrate the courage, valour and dedication of the inhabitants of the city.

Boer War

The first two are amply described in the volume *Historic Newport* written in 1910 by James Matthews, librarian of Newport public library. He writes floridly of the actions of the Earl of Stafford and his men in responding to the royal summons to war in 1346:

> The Gwentian archers had a worldwide celebrity for the excellence of their shooting. The Newport contingent, after attending divine service, filed out of the Castle by the drawbridge into High Street and on to Southampton via the river bridge, Christchurch and Gloucester, amidst a demonstrative ovation by the inhabitants of the town.

Capitalising on civic pride and glory, there was no holding James Matthew:

> Following the fortunes of the Newport men, it is recorded that they were in the first division of the army under the Black Prince [son of Edward III]. When the glad tidings arrived of the great and glorious victory gained by British arms against fearful odds at the Battle of Crecy, which was fought on Saturday 26th August 1346, bells were set ringing everywhere for joy at the news.

More surprisingly, he draws a close parallel between the French War of 1345–47 and the story of the South African War of 1899–1901{

> There were dark days for the [home] nation in December 1345, as well as December 1899. The population of Britain was moved to its very depths and the flower of her people went forth to do battle for her honour on both occasions.

Referring to the memorial tablet dedicated to Newport's heroes who went to the South African War, James Matthews cannot resist further patriotic emotions. He writes,

> Remember the 100 men who left Gwent to do and die or England's [sic] honour on a foreign soil: these 100 Britons – the South Wales Borderers – earned a name, the envy of the world'!

1st Mon. Volunteer Artillery

This jingoistic attitude existed in the early days of the Boer War as reported in the *South Wales Argus* on 30 December 1899:

> There was an exceptionally strong muster at the Drill Hall, of the Newport Battery of the 1st Mon, Volunteer Brigade of Position Artillery on Friday night, for the purpose of showing their part in popular enthusiasm, for active service in South Africa. The officers present were

Lieutenant Colonel Wallace, commanding the Brigade; Major Clifford Phillips; Lieutenant E M Linton; the Rev. W Monroe, chaplain; and Lieutenant J B Parnall.

Major Clifford Phillips said they were willing to go to the front. He had asked Sgt Major Smith to prepare a roll of the men who wanted to go, stating their ages, occupations, experience and circumstances, so that they may know exactly what their position was. Men who were accepted, would have to do drill for a week or so at Woolwich, with 15 pounder breech-loading guns and then they would be sent to the front.

The First World War

James Matthews was not the only Newportonian to invoke English history to justify and encourage Welsh involvement in twentieth-century conflicts. Arthur Machen, born Arthur Llewellyn Jones in Caerleon in 1863, rose to fame as a journalist in 1914 – the first year of the First World War. He wrote *The Bowmen,* setting his story at the time of the British Army's retreat from Mons in August 1914. Phantom bowmen from the Battle of Agincourt are summoned by a soldier calling on St George and destroy the German host. Such 'fake news' metamorphosed into the legend of the 'Angel of Mons' in which the Bowmen became angelic warriors, giving divine help to the British and French armies.

Monmouthshire Regiment, 1915

The dreadful roll call of dead and wounded in the first months of the First World War had a major impact on the psyche of Welsh soldiers and civilians. By the time of the Second Battle of Ypres (23 April to 25 May 1915) there appeared a much more prosaic attitude to battles and commemoration.

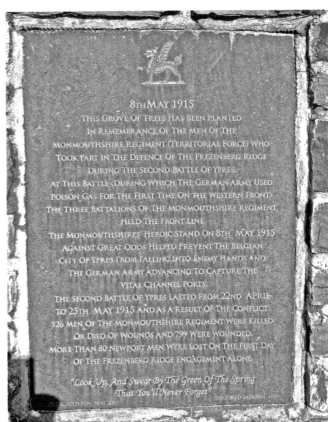

8 May 1915.

This is evident in the painting by Fred Roe. According to Shaun McGuire's 'Newport's War Dead' entitled *The Eighth of May (1915)*, the painting depicts Captain Harold Thorne Edwards firing his revolver at advancing German troops. Captain Edwards was offered the chance of surrendering to the Germans but replied with the words 'surrender be dammed'. For those seeking further information and inspiration, there is a new memorial on the west bank of the River Usk, near to the City Bridge. It is dedicated to the men of the Monmouthshire regiments who, during the Second Battle of Ypres, saw the first mass-use by Germans of poison gas on the Western Front, and who gave their lives at the Battle of Frezenberg Ridge (8–13 May). It highlights the fact that more than eighty Newport men died on the first day of the battle – probably the largest casualties suffered in a single day by any Welsh city or town.

The Second World War – British Resistance, 1940–44

The most secret element of Newport's history was the establishment of a 'secret army' in 1940 to defend the United Kingdom against German invasion. Obviously, it was not called 'secret' for that would have given the game away to our enemies. At the time it was named GHQ Auxiliary Units; subsequent documentation uses the title 'British Resistance Archives' with the website www.coleshillhouse.com taking its title from the organisation's headquarters and training centre in Oxfordshire.

In essence, this secret army – the Auxiliary Units – comprised specially trained, highly secret groups of volunteers created by the British government with the aim of resisting the expected occupation of the United Kingdom by Nazi Germany. These guerrilla units were initiated by Prime Minister Winston Churchill in June 1940 under the leadership of Colonel

Operational base (OB) Coed Y Careau. (Courtesy of Coleshill Auxiliary Research Team)

Colin Gubbins. The Auxiliary Units answered to GHQ Home Forces and were organised as if part of the local Home Guard.

The remit of the units was nighttime sabotage, attacks on ammunition dumps, intelligence gathering and assassinations behind the front line of any German advance. During the day the operational patrols, seven to ten men strong, would lie up in underground hideouts known as operational bases (OBs). By the end of 1941 there were an estimated 534 OBs in place across the United Kingdom; of this, eight units were in operational bases in Monmouthshire, of which two were within the present-day boundaries of the city of Newport. It is pleasing to relate that each had a biblical code name i.e. Bassaleg 'Moses' Patrol and Langstone 'Jonah' Patrol. The British Resistance Archive has little information about Moses Patrol beyond the names of individual members and a generalised account of their training.

It is exceedingly fortunate that Sallie Mogford has written and talked about the experiences of her grandfather Leslie Bulley and great-uncle Charles Bulley, who were key members of Jonah Patrol in Langstone, Newport.

Sallie is county information officer for Coleshill Auxiliary Research Team and has kindly given her permission to use edited extracts and photographs from the archives.

Patrol Targets
Jonah Patrol was to emerge from the operational base (OB) at night, sabotage enemy food and fuel supplies, transport links and aircraft. They were to wreak havoc on the enemy and slow their deadly advance across Wales. Afterwards, they were to return unseen back to the relative safety of the OB. Their mission was considered so dangerous that they were not expected to survive for more than two weeks. The patrol would only venture to the OB in darkness, moving through thick undergrowth on their stomachs to avoid detection. Their greatest fears if there had been invasion was the swift discovery of their OB by German sniffer dogs and spotting of their telltale tracks by German reconnaissance planes repeatedly flying overhead. The Germans would have considered them as spies. They would either have been shot on sight or tortured for information on the set up of resistance cells. If capture by the enemy was certain, no man from Jonah Patrol could be taken alive. Each man had to agree to shoot each other or blow himself up using their own considerable supply of explosives. After the war, it was generally acknowledged that Jonah Patrol was the most highly trained and deadly of all the Monmouthshire Auxiliary Units.

Operational Bases
The royal engineers were utilised to construct the operational bases, which typically consisted of a semicircular corrugated-iron main chamber, a smaller secondary chamber and an escape tunnel. The corrugated-iron chamber was sometimes known as an elephant shelter because of the thickness of the metal. The royal engineers were brought in from outside the area, sometimes as far away as Scotland and were ignorant of the true purpose of the structures they were building. Backfilling and camouflage were carried out under cover of darkness by the patrol themselves. Surplus soil was deposited well away from the bunker. A path was situated nearby, which allowed for footprints and foliage disturbance to be easily explained. All OB's were situated near a source of fresh water.

Coed Y Careau Operational Base
Deep in Wentwood Forest on Coed Y Careau Common, Langstone, lie the remains of the operational base used by Jonah Patrol, nominally part of Monmouthshire 202 Battalion Home Guard. The base lies off a wooded path, hidden underground and cleverly disguised by beech trees and vegetation. From the brow of the hill, eleven counties and the Bristol Channel can be clearly seen. It was here that seven local men waited for the code word

Operational base (OB) interior. (Courtesy of Coleshill Auxiliary Research Team)

'The Balloon's Gone Up', the signal for them to go into action against a German invasion. Located around 40 metres north-east for the main OB, there is a surviving ammunition and storage bunker. The OB was sunk underground to around 4 metres and measured approximately 4 by 3 metres. Ingenious ventilation was installed inside the main chamber, with a ventilation pipe connected to a hollowing in the tree trunk of a nearby tree. A hollow tree trunk was fixed above the secondary chamber ventilation pipe and used as a chimney. A brick-built entrance shaft was constructed with an iron ladder for easy access. The 2-metre-deep shaft was covered by an ingenious wooden soil-filled trough, hinged at both ends. The hinged lid opened in the centre just enough for a man to get through and was planted with vegetation.

The main chamber was fitted out with bunks for six men, a table, cooking stove, paraffin lamps and a chemical Elsan toilet. Stoves were provided to try and alleviate the condensation problem, but apparently they never worked. It was not realised at the time that paraffin would exacerbate the problem. The 20-metre-long escape tunnel was constructed of corrugated iron and wood, and came out into a nearby disused quarry. From the exterior, the OB was completely invisible. Each member had their own identification marble. This was rolled down a ventilation pipe to alert their comrades of their arrival.

Training

A group training course with target practice was arranged every four to five weeks at the derelict Glen Court mansion. Locally, Jonah Patrol used Wentwood Forest for training exercises along with Pertholey House and Belmont House. An annual training camp with members from other patrols was held at Southerndown, with the men billeted at Dunraven Castle. The most memorable part of the training was at Coleshill House headquarters, near Swindon. The organisation was so secret that on arrival the men had to report to Muriel Stranks, who was

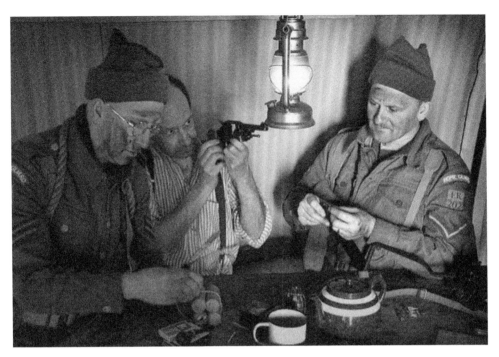

Inside operational base. (Courtesy of Coleshill Auxiliary Research Team)

the postmistress at Highworth Post Office. After checking credentials, she would summon whatever transport was available to take them to the Headquarters.

The men were taught how to make sticky bombs, use a selection of guns, grenades, fuses and pencil bombs. Each patrol was issued with Fairbairn Sykes and Bowie knives, which were particularly lethal weapons. The men were instructed in advanced 'thuggery' and became highly skilled in how to kill silently using knives or the cheese cutter garrottes. An innocuous buff-coloured book, called the *Countryman's Diary 1939* was issued to the men. It was designed to sit innocently on any bookshelf disguised as a seed and fertiliser catalogue. The true contents of the book were explosive – literally! The manual gave instructions on how to make bombs and blow up railway lines, bridges and petrol dumps.

By 1944 the threat of invasion seemed less likely and the need to set up and maintain the secret army diminished. In November they were ordered to stand down. The remains of the operational base and ammunition bunker are now protected as scheduled ancient monuments, structures of national historic importance.

5. Newport Heroes

Lady Rhondda

Margaret Haig Mackworth, 2nd Viscountess of Rhondda was a Welsh peeress, businesswoman, active suffragette and women's rights campaigner. She survived the sinking of the *Lusitania* in 1915.

Margaret Haig Thomas was born on 12 June 1883 in London. Her parents were David Alfred Thomas, 1st Viscount Rhondda, and Sybil Haig, also a suffragette. In her autobiography Margaret wrote that her mother had prayed passionately that her baby daughter might become feminist. She did indeed become a passionate activist for women's rights. She was an only child and although she was born in London, she lived in Llanwern near Newport until the age of thirteen when she went away to boarding school. In 1902, aged nineteen, she took up a place at Somerville College, Oxford, where she studied History. Despite her tutors providing positive feedback on her academic progress, she returned to Llanwern to live with her family after two terms.

In 1908, she joined the Women's Social and Political Union (WSPU) and became secretary of its Newport branch and a supporter of its militant campaign. Between 1908 and 1914 she took the campaign for women's suffrage across South Wales, often to hostile and stormy meetings. She was involved in protest marches with the Pankhursts, jumping onto the running board of Liberal Prime Minister H. Asquith's car in St Andrews and attempting to destroy a postbox on Risca Road, Newport, with a chemical bomb. These activities resulted in a trial at the Sessions House in Usk and her serving a period of time in the prison there. She was released only after going on a hunger strike. In her biography, *Turning the Tide*, Angela V. John describes how Lady Rhondda dropped the incendiary package into 'the letter box on the cemetery wall'. The

Lady Rhondda. (Courtesy of Julie Nicholas)

smoke was extinguished, the letters recovered and the postbox still survives. Today, the red of the box contrasts with the blue of the plaque on the adjacent house on Risca Road.

On the outbreak of the First World War, she accepted the decision by the WSPU to abandon its militant campaign for suffrage. She worked with her father, who was sent by David Lloyd George to the United States to arrange the supply of munitions for the British armed forces. In May 1915, she was returning from the United States on the RMS *Lusitania* with her father and his secretary Arnold Rhys-Evans, when a German submarine torpedoed it. The trio were among the survivors.

The sinking of the *Lusitania* was one of the most horrific incidents at sea during the First World War (1914–18). In early 1915, the German government declared that all Allied ships would be in danger of attack in British waters. *Lusitania* sailed from New York on 1 May 1915 with 1,962 people on board. On 7 May 1915 at 2:10 p.m., the liner was near Kinsale in Southern Ireland, when she was torpedoed by the German submarine, U-20. She sank in under twenty minutes with the loss of 1,198 lives.

The sinking of this unarmed passenger ship caused international outrage. There were riots in Liverpool and London, as well as other cities around the world. The German government claimed that *Lusitania* was a legitimate target due to the war supplies she was carrying – as were many other British ships. However, British and American enquiries later declared the sinking to have been unlawful.

The following account from the 'Lusitania Resource' gives a real indication of the courage and tenacity of Lady Rhondda. The story begins with her and her father, David Alfred Thomas (known as D. A.) joining Dr Howard L. Fisher and his sister-in-law Nurse Dorothy Conner for lunch on the afternoon of 7 May.

Margaret and D. A. left the saloon, leaving Howard and Dorothy to finish lunch by themselves. D. A. then joked with his daughter, saying, 'You know, Margaret, I think we might stay up on deck tonight. Just to see if you get your thrill.' Before Margaret could respond, they felt the torpedo rock the ship with 'a dull thudding sound'. They were already partially inside the lift, but they stepped back instinctively – a move that would save their lives. D. A. ran over to a porthole to see what had happened, whereas Margaret went upstairs. She then wondered,

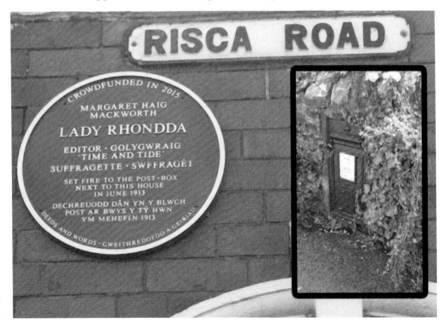

Blue plaque
and postbox.

'Why am I not more frightened?' and started breaking into a run. She then thought, 'Now I'm beginning to get frightened, but I must not let myself.'

As Margaret ran back to her room the electricity went out, and she was in the dark. The ship was also listing heavily and along the way to her room she collided with a stewardess. There the two apologised and laughed about how much time they were wasting at such a moment.

In her room, Margaret grabbed a lifebelt for herself and she ran into her father's room (B-88) to grab his, hoping that they would meet on deck. She ran up the companionway to A-Deck portside, but did not find her father. She did, however, run into Howard Fisher and Dorothy Conner and asked if she could stay with them while she waited for her father. As they waited, they watched with dismay as all order on the ship degenerated into panicked chaos. 'I always thought that a shipwreck was a well-organised affair,' Margaret commented. 'So, did I,' replied Dorothy, 'but I've learnt a devil of a lot in the last five minutes.'

The three had seen what was probably lifeboat No. 12 spill half of its load; Margaret turned away. Just then Dr Fisher realised that he and Dorothy, who had come up on deck directly after lunch, did not have their lifebelts.

When Howard returned, wet and telling of how fast the ship was flooding, the women were jolted back into realising what danger they were in. Margaret unhooked her skirt to enable her to swim in the water, even though she didn't know how. The three planned to jump from the ship, after seeing other lifeboats capsize before reaching the water. It was bad enough that Margaret did not know how to swim and it was even worse that she was afraid of heights. A-deck, under normal conditions, was 60 feet above the water. She saw Howard slip through an open space on deck and Dorothy climb over the rail. Margaret chided herself, telling herself how ridiculous it was to be afraid of jumping when her life was in such danger. Her fear of heights, however, came to naught. The water was rising so fast that before she could jump the water had already risen to her level and swept her, as well as the crowd, off the ship. Margaret was taken down and her wrist was caught on rope. She pulled free, but the rope left a permanent mark on her wrist. She swallowed a lot of water at first, but then she shut her mouth to stop it. She noticed that she couldn't move through the water properly and realised that she was still carrying the extra lifebelt for her father.

Upon reaching the surface, she grabbed a thin piece of board, thinking that the board was keeping her afloat when the lifebelt was what was truly keeping her buoyant. A man with a yellow moustache came alongside her and also grabbed onto the board. He was making his way around to Margaret's side, but Margaret, fearing that he would upset the board or even try to use her as a flotation device, told him to move back to where he was. After a while, she noticed that the man had disappeared.

Hypothermia was taking hold of her and Margaret soon lost consciousness. When the *Bluebell* picked her up, she was clinging onto a wicker chair. Although the boat's captain, John Thompson, believed that she was alive, others weren't so sure. The men laid her on the deck to avoid crowding the cabins. When she awoke she found herself covered in blankets, but without clothes. Three sailors, seeing that she had revived, promptly helped her inside to the captain's cabin, where she fell asleep. Awaking, she heard a woman, emotionally scolding Captain Turner, also on board the *Bluebell*, at the lack of organisation and discipline on board during the sinking, which had led to her baby's death. A sailor bringing Margaret a cup of tea apologised for the woman's outburst, saying, 'I'm sorry, I'm afraid that lady is hysterical.' Margaret's answer was, 'On the contrary, that woman is the only one aboard the *Bluebell* who is not hysterical.'

The *Bluebell* reached Queenstown, Ireland, at 11 p.m. Margaret, much too weak to step into the gangplank, crawled ashore in a khaki army greatcoat borrowed from a solider to her father, who was waiting for news of her on the quay. Afterwards they went to stay at the Queen's Hotel. Dorothy, still in her fawn tweed suit, came to visit Lady Mackworth the next morning

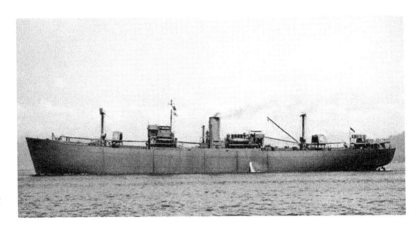

SS *Fort Chilcotin.* (Photographer unknown)

before parting ways. Dorothy updated Margaret that Howard was safe. Lady Mackworth and D. A. Thomas went home to Wales; Dorothy and Howard continued on to work on the battlefields of France.

It was said that Margaret's brush with death left a deep impression on her. She believed that her life had been saved to give it additional purpose and direction. Later in life, she became a deeply religious and very devout Christian.

In 1917, Lady Rhondda became the director of the Women's Department of the Ministry of National Service. The following year, the government recognised the right of women to vote; David Alfred Thomas was named Viscount Rhondda but died in July 1918.

After her father's death, Lady Rhondda tried to take his seat in the House of Lords, citing the Sex Disqualification (Removal) Act 1919, which allowed women to exercise 'any public office'. The Committee of Privileges, after an initially warm reaction, eventually voted strongly against Lady Rhondda's plea. She was supported for many years by Lord Astor, whose wife Nancy had been the first woman to take her seat in the House of Commons, but Lady Rhondda never entered the Lords.

She succeeded her father as chairman of the Sanatogen Company in February 1917. In 1920, she founded *Time and Tide* magazine. In total, she was a director of thirty-three companies throughout her life, having inherited twenty-eight directorships from her father. The majority of her business interests were in coal, steel and shipping. Passionate about increasing the amount of women in the corporate world, Margaret was involved in creating and chairing the Efficiency Club, a networking organisation for British businesswomen.

In 1921 she set up the Six Point Group, an action group that focused heavily on the equality between men and women and the rights of the child.

Less than a month after Lady Rhondda's death in 1958, women entered the House of Lords for the first time thanks to the Life Peerages Act 1958; five years later, with the passage of the Peerage Act 1963, hereditary peeresses were allowed to enter the Lords.

In 1908 she had married Sir Humphrey Mackworth, but they divorced in 1923 and she never remarried. She did have some significant relationships over the course of her life. She lived with *Time and Tide* magazine editor Helen Archdale in the late 1920s and subsequently spent twenty-five years living with writer and editor Theodora Bosanquet.

Edward Alfred Dyer

British Empire Medal (Civil Division) and boatswain on *Fort Chilcotin*. This vessel was torpedoed and sunk on 24 July 1943, having detached from convoy JT2 on 22 July in the South Atlantic, some 370 miles south, south-east of Bahia.

The *London Gazette* supplement of 18 April 1944 reports,

> The ship ... was torpedoed. The engines were stopped by the explosion. The crew had left the ship in boats and on rafts when a second torpedo hit the vessel causing her to sink almost immediately. The survivors were collected into two of the boats, which were kept together until they were both picked up five days later after making a voyage of 300 miles.
>
> Boatswain Dyer displayed courage and exemplary behaviour throughout. After the ship had gone down, the submarine surfaced among the boats. The Boatswain was taken aboard the submarine for questioning. He was returned to his boat and thereafter, during the boat voyage, he did extremely good work setting an excellent example to all.

In a more detailed account of the incident, Boatswain Dyer emerges with even greater credit for his leadership, sense of responsibility and calmness under pressure. This is even more remarkable given that Edward's father, Edwin Dyer, was killed on 25 or 26 April 1917 when a German submarine, U-69, sunk the British steamer SS *Vauxhall*. Although Edward Dyer was just seventeen months old at the time of his father's death, he must have been aware of his father's fate and the likelihood of history repeating itself in the vastness of the Atlantic Ocean. To continue the narrative,

> U-172 surfaced shortly afterwards and approached the motor boat, asking for a man to come aboard for questioning. The boatswain volunteered and told the German captain [Carl Emmerman] that the master and chief officer went down with the ship. He was asked where the ship was bound and if he had heard about the sinking of 'African Star', Harmonic and other ships, but gave only vague answers. After about 15 minutes the boatswain was allowed to return to the lifeboat before the U-boat left. He later described the commander as very civil, who expressed his regret at having had to sink his ship and also wanted to hear his

Boatswain Dyer BEM.

opinion regarding the outcome of the war. The survivors recovered the stores from the rafts and righted the two smaller boats. With 38 men in the motor boat and 15 in one of the smaller boats they found the other boat was not required and left it behind when setting sail in fine and clear weather at a speed of about 3 knots. They had plenty of food and water and went distress signals from the emergency set each morning but received no replies. At 09.03 hours on 29th July, they were picked up by the Argentine steam tanker 'Tacito' after attracting her by firing red flares when her lights were spotted at daybreak. The tanker hoisted both lifeboats aboard and took them to Rio de Janeiro, arriving on the morning of 1st August.

The author assumes that Carl Emmerman conducted the 'interview' in English. Carl Emmerman was a very successful U-boat commander who survived the war and died in 1990. For completeness, Edward Dyer also survived the war, living until 1985 and leaving mementoes and memories at the Mission to Seafarers, Newport.

Tom Toya Lewis

'Little' Tom Lewis became the unexpected hero of the Newport Dock Disaster of 1909. He was a newspaper boy aged fourteen who lived in Wallis Street and whose father worked on the docks as a stevedore. Responding to the emergency call of the whistles, he joined the rescue

Right: Albert Medal presented to Tom Toya Lewis. (Photographer unknown)

Below: Watch presented to Tom Toya Lewis. (Photographer unknown)

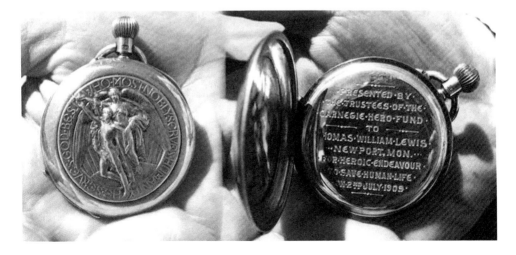

effort. When an injured man was found alive amid the wreckage of broken beams and twisted metal, Tom climbed through the narrow gap in the timbers to a depth of 60 feet. He sawed desperately for hours at the beam, trying to free Fred Bardill. He managed to release one of his limbs but before he was able to lead him to safety another fall started. There was a groan and the timbers began to shift. The decision was made to pull Tom from the trench. He emerged, cut and bloodied, into the arms of the rescuers, sobbing for the trapped man. Thanks to Tom's efforts Fred was pulled free in the hours that followed – the last man to leave the trench alive.

As a mark of his bravery Tom was invited to tea at Buckingham Palace and presented with the Albert Medal by Edward VII in December 1909. The medal is the highest award for civilian bravery on land in peacetime and bears the inscription: 'Presented by His Majesty to Thomas Lewis for gallantry in saving life at the Dock Extension Works, Newport (Mon), on the 2nd July 1909.'

Tom also received a pocket watch 'presented by the trustees of the Carnegie Hero Fund to Thomas William Lewis Newport Mon, for Heroic Endeavour to save human life on 2nd July 1909'.

The formal recognition given to Thomas (Tom) Lewis does not include the middle nickname of 'Toya'. Although there is no formal record of this name, it lives on in the title of the present-day Wetherspoon's pub in Commercial Street. It is interesting to note that the 'John Wallace Linton', the other Wetherspoon's pub in Newport named after a valiant local hero, does not feature his nickname of 'Tubby' Linton.

John Wallace Linton VC DSO DSC

John Linton, commander of the Royal Navy and known as 'Tubby', was born in Newport and is the only Newportonian to win the Victoria Cross. His father was E. Maples Linton, a local architect who lived on Chepstow Road. Tubby was educated at the Royal Navy Colleges at Osborne House, Isle of Wight and Dartmouth, Devon. He joined the Royal Navy as a midshipman on HMS *Dauntless* in 1923, volunteering for the submarine service in 1927. Described as a talented sportsman, he played rugby for the Royal Navy.

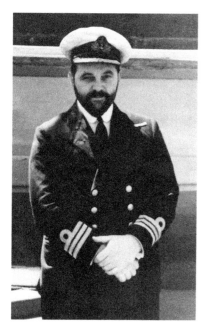

John Wallace Linton VC DSO DSC.
(Courtesy of rnsubs.co.uk)

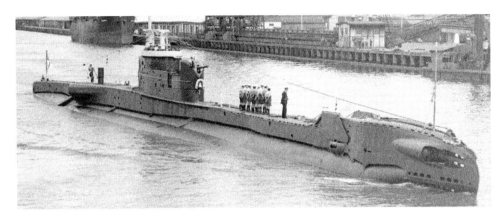

T-Class submarine. (Courtesy of rnsubs.co.uk)

When the Second World War broke out in 1939, Tubby was commanding HMS *Pandora* in the Far East before being transferred to the Mediterranean Sea in early 1940. Based with the 8th submarine *Flotilla* at Gibraltar, he was awarded the Distinguished Service Cross (DSC) for the sinking of two Italian supply ships.

After returning home in August 1941, he was promoted to commander in December of that year and took command of HMS *Turbulent*, newly built and commissioned at Vickers Armstrong Shipyard at Barrow-in-Furness. This time based at Alexandria in Egypt, he was awarded the Distinguished Service Order (DSO) for sinking the Italian Destroyer *Emanuele Pessagno* on 29 May 1942.

On 3 February 1943, HMS *Turbulent* sailed from Algiers for a patrol in the Tyrrhenian Sea. *Turbulent* did not respond to any further messages and did not return when expected on 23 March. It is thought that *Turbulent*, her captain and crew fell victim to a mine off the La Maddalena, Sardinia.

John Wallace Linton was awarded the Victoria Cross on 25 May 1943. Unusually the award was not for any specific incident but was for sustained effort. The citation reads,

The KING has been graciously pleased to approve the award of the VICTORIA CROSS for valour in command of H.M. Submarines to:
Commander John Wallace Linton, D.S.O., D.S.C., Royal Navy
From the outbreak of war until H.M.S. 'Turbulent's' last patrol Commander Linton was constantly in command of submarines and during that time inflicted great damage on the Enemy. He sank one Cruiser, one Destroyer, one U-boat, twenty-eight Supply Ships, some 100,000 tons in all, and destroyed three trains by gunfire. In his last year, he spent two hundred and fifty-four days at sea, submerge for nearly half the time, and his ship was hunted thirteen times and had two hundred and fifty depth charges aimed at her.

His many and brilliant successes were due to his constant activity and skill, and the daring which never failed him when there was an Enemy to be attacked.

On one occasion, for instance, in H.M.S. Turbulent, he sighted a convoy of two Merchantmen and two Destroyers in mist and moonlight. He worked round ahead of the convoy and dived to attack it as it passed through the moon's rays. On bringing his sights to bear he found himself right ahead of the destroyer. Yet he held his course till the Destroyer was almost on top of him, and, when his sights came on the convoy, he fired.

His great courage and determination were rewarded. He sank one merchantman and one Destroyer outright, and set the other Merchantman on fire so that she blew up.

John Wallace Linton,
Cambrian Road.

The heroism of Tubby Linton is commemorated in a number of ways around Newport. Most notably the Wetherspoon's on Cambrian Road is named John Wallace Linton. His name features on a blue plaque at the St Joseph's Convent, Malpas, on the house where he was born. There is a further memorial on Kutaisi Walk on Newport's riverfront

Ivor John Tilley, Distinguished Service Medal (DSM)

This story of heroism and bravery began with the most slender of clues. In the book of remembrance at the Mission of Seafarers there is the name Tilley, Ivor J. with the initials 'D. S. M.' in red, a silver medal showing the head of George VI and a blue-and-white striped ribbon. Following these, the author found the relevant entry in the *London Gazette*, dated 22 December 1942:

> For fortitude and endurance in taking Merchantmen to Russia through heavy seas and the face of relentless attacks by enemy aircraft and submarines.
>
> The Distinguished Service Medal
> Greaser Ivor John Tilley

These citations led to identifying the ship as *Empire Tide*, a catapult-armed merchantman that was part of ill-fated Convoy PQ 17, to the award of the Distinguished Service Medal, and a visit to Buckingham Palace described in an article in the local paper, along with a twelve-page family history.

Did You Know?

Ivor John Tilley DSM carried with him on his many voyages in the British Merchant Navy, a pressed flower from his bride's wedding bouquet, the New Testament Bible, copies of 'The Pilot's Psalm' and a prayer to Saint Camillus. These items are in the possession of Mrs June Eacott, Ivor's youngest daughter; she is unable to explain the inclusion of a prayer from the monastic order of St Camillus in Killucan, Co. Westmeath, Ireland, which was founded in the sixteenth century by an Italian mercenary soldier to care for the sick and the dying.

30th November 1943 - Buckingham Palace - Ivor Tilley - recieving DSM for conduct on Russian Convoy
Percy & Clara George, Florence & Ivor - William & Albert Tilley, Francis & Charles George

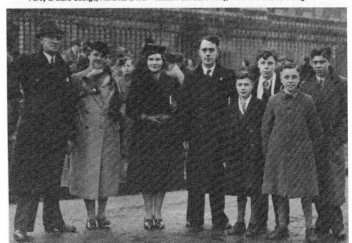

Ivor John Tilley DSM,
Buckingham Palace,
1943. (Courtesy of Tilley
family)

James William Tilley standing with his sons
Albert Edward and Ivor John.
Ivor's cap badge is of the South Lancashire Regiment.

Ivor John Tilley, South Lancashire Regiment, 1916.
(Courtesy of Tilley family)

These contained important summaries of his life, military service and Merchant Navy career, and details of *Empire Tide* sailing in PQ 17 from Iceland to Russia in 1942. In addition, there are accounts of the voyage, adventures and fate of *Empire Tide* and PQ 17 in the archives of the Imperial War Museum. The book *Atlantic Jeopardy – PQ 17 Convoy to Hell* by Paul Lund and Harry Ludlum provides grim first-hand testimony.

Ivor was born on 4 September 1899 at No. 10 Jones Street, Newport. He began school at St Woolos Infants and progressed to St Woolos Boys School in 1907. To say that Ivor was a patriotic and restless is an understatement. Military records and family recollections showed that on three separate occasions he overstated his age in attempts to join the South Wales Borderers, the Royal Navy Volunteer Reserve (RNVR – 2/1819) and the Monmouthshire Regiment. Each time when his true age was revealed, sometimes following his father's intervention, he was discharged. Nonetheless, he received a British War Medal from his time in the RNVR.

Finally, he joined the 1/5th South Lancashire Regiment in 1916 and was posted to France. The battalion was involved in the Battle of the Somme in 1916, together with the Third Battle of Ypres and Cambrai in 1917. In that November he was gassed and discharged; he came home on a fourteen-day leave with 55th Division. His niece wrote, 'He had lost his kit in France, including a horse, and was fined 51 shillings.' He was given a pension of £2 per month.

He re-enlisted in the Army as Private 80277 South Wales Borderers and lost his pension. This time he was sent to India; after he arrived there he received a letter saying that his fiancée, Florence, who later became his wife, was pregnant. He married her on 15 April 1922 as soon as he got home, which was two years later. He was awarded two Campaign Medals, a British War Medal and a Victory Medal.

Ivor joined the Merchant Navy in 1924, where he served for the next thirty years. He took a job at Alcan, Rogerstone, Newport, in 1954. He sadly died in 1962, and his medal was donated by his children to the then Seaman's Mission, Newport.

Convoy PQ 17, July 1942

As the name implies, PQ 17 was one of a series of convoys sailing under Royal Navy escort from Reykjavik in Iceland to Archangel in northern Russia from 1941. The Germans were initially slow to intervene but from their bases in northern Norway they began to inflict terrible losses on these convoys. The British and Americans had to combat not only the arctic weather conditions and the permanent threat of an air or U-boat attack but also the possibility that powerful German ships like the Tirpitz might break out and attack. From spring 1942, the convoys faced the ordeal of the arctic weather as well as relentless attacks from strong German sea and air forces based in Norway. Sailing in continuous daylight, the ships were especially vulnerable. The 2,500-mile voyage took convoys to within 750 of the North Pole.

Seamen had to undergo a special medical examination before sailing because of the extreme arctic weather conditions. If they were passed as fit, they were issued with extra-thick clothing to help them withstand the cold. Duffle coats were lined with lambswool and had extra hoods, with only slits for the eyes and mouth.

Ivor served aboard *Empire Tide*, a catapult-armed merchantman and one of the few ships to make it through. Only eleven ships out of thirty-five starting out in Convoy PQ 17 reached Archangel; just two were British, the *Empire Tide* and the *Ocean Freedom*. A contemporary account by Chief Steward Horace Carswell described

> Our enemy alter course and steamed due east through a sea/a-glitter with Hoe-ice. We reached a position near Bear Island ... the zone of greatest danger, lying within easy range of the German air-bases and ... the alarm bells were soon ringing for 'Action Stations'. Between 40 and 50 Jerries came racing in from all directions ... that filled the Arctic sky with the thunder of high-powered engines. It was the Fourth of July. Fragments of ice from the shattered floes spattered our decks. Warships and Merchantmen combined to fill the sky with the fury of high explosives. The rain of steel made you thankful for a tin 'battle bowler', inadequate protection though it was.

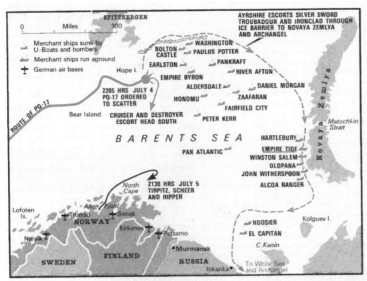

Above: Map PQ 17.
(Unknown origin)

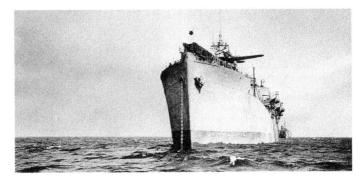

PQ-17 was the most disastrous of the Russian convoys: out of the 33 ships which had left Iceland, 23 were lost—and the abortive sortie of the *Tirpitz* had never gone anywhere near the ill-fated convoy. The Allied hope that the German heavy ships would be tempted within the reach of the Home Fleet's battleships also came to nothing. And when the U-boat commanders realised that the convoy had broken formation and headed east, they concentrated in the waters between Novaya Zemlya, Spitzbergen, and the White Sea—with deadly effect

In making Moller Bay, the *Empire Tide* struck an uncharted rock.... But the ship was repaired and refloated, and set off unescorted to Archangel.

Right: Empire Tide.
(Photographer unknown)

Our captain decided to make for temporary haven at Novaya Zemlya. On the way, we picked up 148 survivors from lifeboats adrift – men suffering from exposure and frostbitten hands and feet.

In making Moller Bay, the *Empire Tide* struck an uncharted rock ... But the ship was repaired and we set off unescorted ... to Archangel ... when the look out in the crows-nest reported to the bridge: 'Object on the starboard bow, sir!' On closer inspection, they proved to be the foremast and stern of a sinking ship and three lifeboats manned by survivors. The crew of the torpedoed ship were got aboard, some of them suffering from frostbite due to immersion in the icy water before being hauled into the boats.

Our captain decided to make a wide sweep of the area in case other hapless crews were adrift. The search resulted in the rescue of survivors from two other torpedoes vessels. From this and other warnings, there appeared to be small hope of the *Empire Tide* making a lone voyage to Archangel in safety. So, we ran back to Moller Bay where ... we found four corvettes and an equal number of merchant ships that had arrived after various misadventures. A small convoy formed, and without further interference we reached Archangel to deliver our cargoes.

At the time, some 2,000 British and Allied seamen – survivors from aircraft and U-boat attack – were housed in the In tourist Club, a huge logwood building surmounted by the Union Jack and Soviet flag. Our arrival with munitions and supplies was greeted cordially by Russian officials, but there were no wild demonstrations of welcome by the people. After our

ship had made a call at Molotov, a new port about forty miles from Archangel, a convoy of 12 ships was formed for the homeward voyage (QP.14). Again, we had to run the gauntlet of the Polar route, and were frequently attacked by hostile aircraft and finally by a U-boat pack.

His family added,

Ivor was awarded the Distinguished Service Medal for his bravery on a Russian convoy. Ivor was a 'greaser' in the Merchant Navy and was with the ill-fated Convoy PQ 17- as one of the 34 ships that left Iceland for Archangel, Russia. Out of the 34 ships, only 2 British ships returned, and Ivor was on one of them. He was taken straight to the hospital at Whitchurch, Cardiff when his ship docked. Ivor's niece, Lola, was a young nurse at the hospital at that time, and when it was learned that her uncle was a hero, there was great excitement. Ivor was very poorly, but was able to send a message to Lola by another nurse.

The award was announced in the *London Gazette* on 22 December 1942. It was for 'fortitude seamanship and endurance in taking Merchantmen to north Russia through heavy seas and in the face on relentless attacks by enemy aircraft and submarines'.

The book *PQ 17 – Convoy to Hell, The Survivors' Story* regrettably does not mention Ivor Tilley by name. One reason for this may be that the citation for the master, Captain Frank Willis Harvey, and Chief Officer George Edward Leech appeared in the first shortlist published by the Admiralty in the *London Gazette* on 29 September 1942. The citation for 'Greaser Ivor John Tilley' is listed separately in the *London Gazette* for 22 December 1942. In fact, he was employed as a 'Donkeyman' on many of his voyages.

The book contains frequent and thorough mentions of *Empire Tide*, and the whole account reinforces the sense of awe and admiration inspired by the exploits of a greaser from Newport. Those Merchant Navy personnel who served on Russian convoys are commemorated by the memorial on the Usk Valley Walk in Newport by the river between the George Street and City Bridges. The walk itself is a delight and the memorial a prompt to remember the bravery of such men as Ivor John Tilley and his comrades. Ivor deserves more individual recognition in this native city, for example by naming a street after him or placing a blue plaque on his school on Stow Hill.

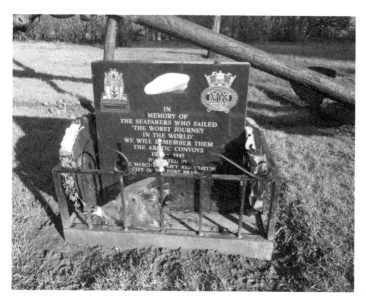

Arctic convoy memorial.

Perce Blackborow

Just over 100 years ago, one of the greatest stories of human endurance and courage unfolded at the ends of the earth, in which a sailor from Newport played his part. Among the twenty-eight experienced polar explorers, sailors and scientists who sailed for Antarctica in 1914 with Sir Ernest Shackleton's crew, was Perce Blackborow, a young seaman from Newport who is famed for being the only person to stow away on an Antarctic expedition. The story begins when two friends travelled to Buenos Aires to look for new ship-going employment.

William Lincoln Bakewell was taken on as an able seaman by *Endurance*. Blackborow, however, was not hired – his youth (he was eighteen) and inexperience counting against him. Fearing that *Endurance* was shorthanded, Bakewell and Walter How helped Blackborow sneak aboard and hid him in a locker. On the third day at sea he was discovered.

Unable to stand, he had to remain seated in a chair when meeting Ernest Shackleton for the first time. Apparently, in a fit of genuine rage, Shackleton subjected the stowaway to a most severe and terrifying tirade in front of the entire crew. This had the desired effect and the reactions of the two accomplices were enough to unmask them. Shackleton finished his performance by saying to Blackborow, 'Do you know that on these expeditions we often get very hungry, and if there is a stowaway available he is the first to be eaten?' Shackleton hid a grin and, after chatting with one of the crew members, said, 'Introduce him to the cook first.'

Blackborow proved an asset to the ship as a steward and was eventually signed on, though the promise was that he would be the first to be eaten should they run out of food or should the men starve.

Following *Endurance*'s entrapment and crushing, the crew relocated to Elephant Island. On arrival Shackleton thought to give Blackborow, the youngest of the crew, the honour of being the first to step on the island, forgetting that his feet had been frostbitten. Helped over the gunwale, he fell in the shallows and was quickly carried ashore.

Perce Blackborow. (Photographer unknown)

On 24 April the rescue party set sail in the *James Caird* for South Georgia, hoping to return in a few weeks. The rest of the crew resigned themselves to waiting and were in poor health and spirits. Blackborow had contracted gangrene and was Macklin's greatest medical concern. On 15 June, with Shackleton and the *James Caird* crew now away for a month, Macklin, assisted by McIlroy, carried out the necessary amputations. Greenstreet described the operation: 'Blackborow had... all the toes of his left foot taken off ¼ inch stumps being left ... The poor beggar behaved splendidly and it went without a hitch ... Time from start to finish 55 minutes. When Blackborow came to he was cheerful as anything and started joking directly.'

After the expedition, Perce spent three months hospitalised in Punta Arenas, Chile, recovering from the frostbite damage sustained to his left foot, which had resulted in the surgeon Macklin and McIlroy having to amputate his toes on Elephant Island on Thursday 15 June 1916.

Blackborow returned to live in Newport and received the Bronze Polar Medal for his service. Perce, it seems, was a modest man, for upon returning home to Wales he avoided the welcoming home party waiting for him at the local railway station by going across the tracks and leaving out of the other side.

He soon volunteered to join the Royal Navy but was turned down because of the lack of digits on his left foot. He was, however, accepted into the Merchant Navy and served until 1919. He went on to become a dock boatman in the Alexandra Docks, Newport, and also fished to help support his family. He married a local girl, Kate Kearns, and they settled in Maesglas, Newport. Perce Blackborow died in 1949 of chronic bronchitis and a heart problem at the age of fifty-three.

Annie Brewer

Annie Brewer is perhaps the most obscure and least known of the Newport's heroes. The author was to hear her story when BBC Wales broadcast *Annie's War: A Welsh Nurse on the Western Front* on 8 September 2014. The programme revealed that Annie Brewer served as a nurse on the front line throughout the First World War and was awarded some of the highest medals for gallantry that the French government can bestow.

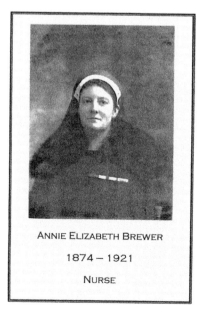

ANNIE ELIZABETH BREWER

1874 – 1921

NURSE

Annie Brewer. (Photographer unknown)

The *Legion of Honour* is the highest French order for military and civil merit, being awarded for extreme bravery. The *Croix de Guerre* 1914–18 is a French military decoration, created to recognise French and Allied soldiers who were cited for valorous service in the First World War, similar to the British 'mentioned in dispatches'. The Medal of French Gratitude was a French honour medal created in July 1917 and solely awarded to civilians; these were defined as persons who, in the presence of the enemy, have performed acts of exceptional dedication, the duration of these services having spanned one year. The medal was created to express gratitude by the French government who, without legal or military obligation, had come to the aid of the injured, disabled, refugees or who had performed an act of exceptional dedication in the presence of the enemy during the First World War. These awards testify to the courage, bravery and dedication of Nurse Annie Brewer, who deserves greater public recognition, not least in her native Newport.

Her great nephew, Ian Brewer, was instrumental in giving an account of her life and achievements to the wider world. His blog post 'Discovering Annie's War' published on the BBC website gives a valuable insight into his research. He wrote,

It all started when we had family parties back in the 1950s at my home. There was much talk about Annie during these occasions.

Apparently, my great aunt was a nurse in WW1 and, as a 10-year-old boy, I was curious to know more.

I was told that great aunt Annie had died in 1921. Postcards sent home by Annie were a regular talking point at these functions as she had travelled widely on the continent.

Annie Elizabeth Brewer was my grandfather's sister and she was often known as Nancy. On one occasion, my grandfather produced a photograph album at one of our parties. There were about 150 photos taken during the war years. As a young boy, I was shocked by some of the photographs.

My great aunt Edith was a sister to Annie and I regularly visited her. It was here that I saw a picture hanging on the wall. It caught my eye because it was an angel flying over an army of soldiers and there were flames in the background. All the writing was in French but my aunt told me it was awarded to Annie for bravery. It was the Angel of Mons citation to accompany the *Croix de Guerre* medal.

After my grandfather dies in 1952, all of Annie's personal belongings were passed to her sister Edith. When Edith died in the 1970s all of Annie's possessions were passed to her niece, Nancy. I was shown various certificates and medals, which intrigued me, and I felt that I had to find out more about great aunt Annie.

For the last 35 years, I have been working on her history and this has involved a great deal of detective work. I could not locate her grave as she had not been buried under the name of Brewer but a bereavement card was unearthed which showed that she was buried under the name of Mistrick.

Sir Briggs – The Original War Horse

The grave of Sir Briggs is in the Cedar Garden of Tredegar House, with the following notable inscription: 'In Memory of Sir Briggs. Favourite Charger'.

He carried his master the Hon. Godfrey Morgan, Captain 17th Lancers, boldly and well at the Battle of Alma in the first line of the light cavalry charge at Balaclava and the Battle of Inkerman in 1854. He died at Tredegar Park on 6 February 1874 aged twenty-eight years.

Sir Briggs was bought in 1851, the same year he won the hunt Steeple Chase at Cowbridge. When the Crimean War broke out, the most sensible thing would have been to send horses and men by steam ship to the Black Sea. It wasn't to be. Sir Briggs set sail from Portsmouth in 1854 on board the *Edmundsbury*, a sailing ship carrying forty horses.

LORD TREDEGAR'S BALACLAVA CHARGER "SIR BRIGGS," AND THE LATE LORD TREDEGAR.

Sir Briggs. (Photographer unknown)

At the Crimea, the cavalry remained largely inactive. It was not until Balaclava that bloody action was seen. The exact number taking part in the Charge of the Light Brigade is controversial and put between 661 and 673. After the charge only 195 came back. Sir Briggs received a sabre cut to the forehead while riding into the 'Valley of Death'.

Godfrey Morgan became sick and returned to Constantinople. Sir Briggs remained in the Crimea with his brother Frederick Morgan and was used as his staff horse. In the same year that Sebastopol fell, Sir Briggs won the military steeplechase there.

In 1855 Sir Briggs returned to Tredegar House, where he was finally buried. Interestingly, Sir Briggs is not only commemorated at Tredegar House but also outside City Hall in Cardiff.

The Charge of the Light Brigade was one of the great mistakes of British military history. The British and French were fighting the Russians on the Crimea and the Light Brigade was ordered to attack a Russian artillery battery – a hopeless task. A verbal order was given by Lord Cardigan, which he immediately tried to cancel but it was too late, the cavalry had charge and could not be stopped.

Some 188 men died and 335 horses were killed or destroyed later. Lord Tredegar described shutting his eyes as he saw a Russian gunner 100 yards away touch the fuse to a gun. It missed Lord Tredegar but hit the man next to him full in the chest. Tredegar's horse, Sir Briggs, fell and pinned him to the Russian gun. The gunner tried to shoot him but Tredegar cut him with his sword. Sir Briggs struggled free and bolted with Lord Tredegar on his back.

The French commander Marshall Pierre Bosquet commented on the fiasco, '*C'est magnifique, mais ce n'est pas la guerre. C'est de la foile*'. ('It is magnificent, but it is not war. It is madness') and Lord Tennyson wrote his famous poem.

Sir Briggs went on to become a champion steeplechaser and Lord Tredegar remained devoted to the horse that had saved his life.

Wilbert Charles Roy Widdicombe

Here is another heroic tale of a merchant seaman from Newport who has neither medal nor blue plaque. Collectively, he is commemorated at the Merchant Navy Memorial, Cardiff Road, Newport. He is remembered by the display at the Imperial War Museum in London of the 'Jolly Boat' from the SS *Anglo Saxon*.

Roy Widdicombe was born in Totnes, Devon, in 1919, writes Adrian Hughes. He became a merchant seaman and married Cynthia Pitman at Holy Trinity Church, Newport, in March 1940. While on shore leave, he lived with his new bride and her mother at No. 96 Lewis Street, Newport.

On 21 August 1940 his ship SS *Anglo Saxon*, belonging to the Lowther Latta Line, was en route from Newport to Bahia Blanca in Argentina with a cargo of coal when it was attacked by the German surface raider *Widder* (disguised as a neutral ship) in the Atlantic Ocean off West Africa. Able seaman Widdicombe was in the wheelhouse when the ship was strafed with machine gunfire and torpedoed. He managed to lower the ship's one undamaged 'jolly boat' into the water, even though he was injured when his hand jammed in the running block.

The seven surviving men, from a crew of forty-one, had few provisions in their lifeboat: a little water and food, a compass and oars. Over the next fortnight, five of the men perished, some as a result of injuries from the attack on their ship. Others threw themselves into the sea, deluded from hunger and thirst. After nineteen days only two remained aboard: Roy Widdicombe and Robert Tapscott.

Seventy days after the SS *Anglo Saxon* had been sunk, the 'jolly boat' grounded on a beach on Eleuthera Island, Bahamas. Barely alive, Roy and Robert had lost half their body weight and were sunburnt to the point of being black. They had survived by eating seaweed and collecting fresh water on the few days it had rained. For the last eight days of their journey they had

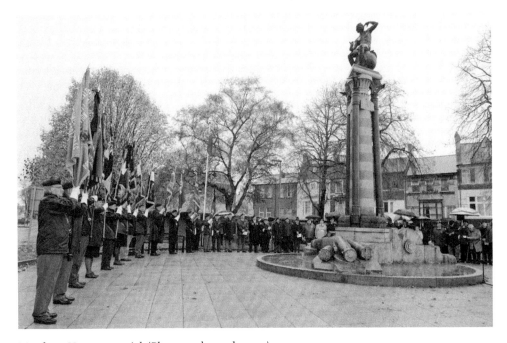

Merchant Navy memorial. (Photographer unknown)

no water and had smashed their compass and drank the fluid from it. They were taken by seaplane to a hospital in Nassau (capital of the Bahamas) where they recuperated over many weeks. In hospital, they were visited by the Governor of the Bahamas, the Duke of Windsor, Edward VII until he abdicated in 1936.

According to one account, their survival created great interest and they toured the United States to promote the plight of Great Britain before the United States had entered the war. Roy's moment of fame was short-lived, as messages were sent from Britain that the Ministry of Shipping needed every sailor it could muster for the merchant fleet. Roy, who was in better physical shape than Robert, travelled back to the United Kingdom. He was only a day away from Liverpool when a German U-boat torpedoed the vessel *Siamese Prince*, off the coast of Scotland, with the loss of all hands.

Ruby Loftus

Her name has been used for the group of new houses on the former No. 11, Royal Ordnance Factory (ROF) site in Newport. Loftus Garden Village honours the site's history and local munitions worker Ruby Loftus, who was immortalised in the famous the Second World War painting by Dame Laura Knight. The painting *Ruby Loftus, Screwing a Breech Ring* showed her work at the factory, which afterwards became a cable factory.

Stella Ruby Isabella, known as Ruby or Bella to her family, was born in Llanhilleth in 1921. In November 1940, together with her two sisters, Elsie and Queenie, she went to work at the new Royal Ordnance Factory. A year later, the factory was the location for a film entitled *Night Shift*, directed by Paul Rotha and made by the Crown Films Unit. It was shown in cinemas throughout Britain in May 1942.

Ruby's initial training on general machining work lasted for a year. Subsequently, she was one of three girls selected to tackle the difficult machining operation known as 'the screwing of the Bofors breech rings'. Making a breech ring was considered one of the most highly

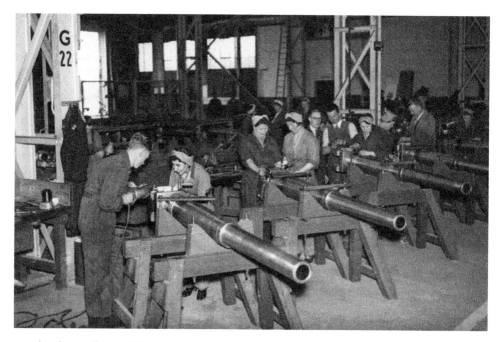

Royal Ordnance factory. (Photographer unknown)

skilled jobs in the factory. This task normally would have required an apprenticeship of eight or nine years; however, because of wartime demands the process had to be speeded up. This was achieved by training machinists to concentrate on individual stages of the production of each gun. In Ruby's case this was the breech ring.

Women were recognised as having an aptitude for this precise work, where the permitted tolerances were no more than two-thousandths of an inch!

Ruby's life was to change in January 1943. She came to the attention of the War Artists Advisory Committee as an 'outstanding factory worker'.

> According to Ruby, Mr Galbraith, Superintendent of the Factory where I worked, sent for me and told me that Dame Laura Knight was coming to the Factory on February 1st to paint me while I was working. Dame Laura was delayed a number of times and eventually turned up in the Factory on March 1st.

Dame Laura Knight's Newport Commission
At this time Laura Knight was the most prominent female artist in Britain and the first woman to be elected to the Royal Academy since 1760. She was commissioned by the War Artists Advisory Committee to produce paintings as war records.

Between 1941 and 1945, for convenience as well as safety, Laura Knight moved from London to Bristol Camp in Malvern. From here she was able to travel easily to the midlands and South Wales to paint. One of her commissions was *Ruby Loftus, Screwing a Breech Ring* at the ROF in Newport. This painting is now in the collection at the Imperial War Museum.

She went to the Newport Ordnance Factory in March 1943 and stayed at No. 64 Cromwell Road, a house belonging to the factory. Over the next three to four weeks she painted Ruby at her factory lathe working on the breech ring of a gun.

> Dame Laura was looked after, during her stay in Newport, by the Superintendent's Secretary Miss Lucinda Holland. As a token of her appreciation Dame Laura presented her with an original sketch which she made in the factory and on which she based the picture in the Royal Academy. The gift was accompanied by a letter from Dame Laura Knight.

The sketch shows his exceptional lathe operator machining and cutting the internal thread of a breech ring for a two-pounder anti-tank gun. While Ruby Loftus continued working, Dame Laura set up, with help, her easel and a temporary low partition guarding her from passing traffic. For the next two weeks or so Dame Laura worked steadily with her busy, ever-moving model.

> Dame Laura Knight set up her easel on the shop floor and painted. She was very self-possessed and worked with the noise of the machines and the cranes all around her, hardly stopping for refreshment. I had to take her by the arm to make her stop for a hot drink.

In April 1943 the factory superintendent, Mr Galbraith, took Ruby by car to the opening of the Royal Academy Exhibition in London. Dame Laura Knight's picture of Ruby was voted 'Picture of the Year'. At the same time, Ruby featured in a newsreel film and took part in a remarkable press conference. As one of her biographers wrote, 'to complete an extraordinary year, Ruby was married to John Green at St John's Church, Maindee in September 1943'. The couple emigrated to Canada in 1948, where Ruby lived until her death in 2004.

Ruby's story shows how people's wartime experienced on the home front could change their lives forever. Her image became a symbol of endeavour, duty and commitment from the day it was painted by Dame Laura Knight in 1943. The picture of the Newport lady is an enduring image recognised all over the world.

6. Newport Culture

Sport: Rugby Union, Soccer, Golf

This chapter looks at popular and more classical culture in the city and features some notable Newportonians. For followers of major sports, such as rugby and football, particularly the union variety of rugby and associated football (aka soccer), the focus is very much on Rodney Parade. This stadium in the city is located on the east bank of the River Usk, a short walk from the city centre and transport hubs across Newport Bridge and Newport City footbridge. The Mecca for golf is the Celtic Manor Resort, home of the 2010 Ryder Cup.

Rodney Parade is the home ground of rugby union clubs Newport RFC and the Newport Gwent Dragons regional team. It is also the home ground of Newport County Football Club and is the second-oldest sports venue in the Football League after Deepdale, Preston, Lancashire.

At the entrance to the ground stand memorial gates, erected to commemorate the members of Newport Athletics Club who fell in the First World War.

Newport Rugby Club was formed in 1874 and within five years they had four invincible seasons. They played the first ever Anglo-Welsh club match with Blackheath and also had time to play the first ever 'electric light' match at Newport in 1879, and they were to be one of the pioneers of floodlit rugby in Wales in the 1960s.

Newport had phenomenal success on the field and in the ten years that the South Wales Challenge Cup was run in the 1870s and 1880s Newport won it five times and were runners-up on two occasions. Newport's success on the field meant they were often called upon to supply players to the Welsh team. Four Newport players played in Wales' first ever match against England – at Blackheath in 1881.

Newport became one of rugby's leading clubs and produced star players season after season. Early names include Tom Baker Jones, Arthur Boucher, Tom Graham, James Hannan, Wallace Watts etc., and then there was Arthur 'Monkey' Gould who was certainly rugby's first superstar. He dominated the game in the latter part of the nineteenth century and one of his records – most tries in a season – still stands to this day. Arthur scored thirty-seven tries in only twenty-four games in 1892/93 and a further two in unofficial matches. The record stood for an incredible 118 years.

At the start of the twentieth century, touring sides from the southern hemisphere became regular visitors to Rodney Parade. In 1912, Newport became the first ever club to beat Bill Millar's South African team and were presented with a Springbok head, which stands proudly in Newport's trophy room today.

After the Second World War, a great side developed at Newport in the late 1940s and 1950s. This was the golden era of Roy Burnett, Ken Jones, Bryn Meredith and Malcolm Thomas and crowds in their thousands flocked to watch. The 1950s saw yet another innovation by Newport: the introduction of seven-a-side rugby in Wales. With great exponents of the game in the guise of Brian B. J. Jones, Bryn Meredith, Brian Price and David Watkins, Newport dominated the game, winning nine of the first fourteen tournaments and being runners-up in another three.

The date 30 October 1963 was to prove to be what many have claimed to be not only Newport's greatest achievement on the field, but the greatest achievement of any rugby club

Rodney Parade. (Photographer unknown)

Memorial gates. (Photographer unknown)

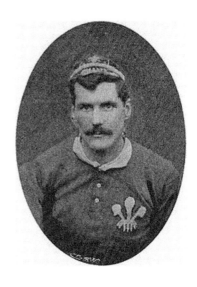

Arthur Gould. (Photographer unknown)

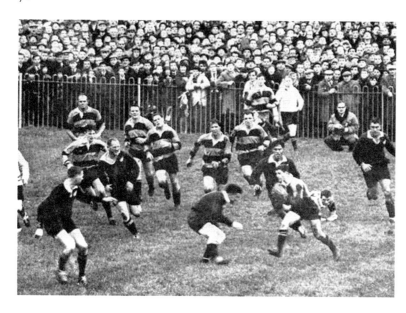

Newport 3,
All Blacks 0.
(Photographer
unknown)

in the world. They were the only side to beat the mighty 5th All Blacks. They had beaten the Wallabies in 1957 and so completed a memorable hat-trick over the three great southern hemisphere sides.

Success continued in the 1960s for Newport; Keith Jarrett, Brian Price, David Watkins and Stuart Watkins were just a few of the many players who became household names. Newport once again beat the Springboks in 1969. They have been runners-up in the Premier League twice as well as once again winning the Welsh Cup in 2001. Rodney Parade has seen international superstars such as Shane Howarth, Gary Teichmann and Percy Montgomery wearing black and amber, and there have been many memorable European Cup games. Once again there was turmoil in Welsh rugby with the introduction of regional sides, but when the Welsh Premier League went semi-professional in 2003/04, Newport RFC duly won it in style, losing only two matches. A fuller history of the club has been written by Mike Dams, Newport RFC historian.

Dragons

Dragons (Welsh: Dreigiau) is one of the four professional Rugby Union regional teams in Wales. It is owned by the Welsh Rugby Union and play all home games at Rodney Parade.

Newport Gwent Dragons played in the Pro12 league, the Anglo-Welsh Cup and the European Rugby Championship Cup/European Rugby Challenge Cup. The region they represented covers an area of south-east Wales including Blaenau Gwent, Caerphilly, Monmouthshire, Newport and Torfaen, with a total population approaching 500,000.

Formed in 2003 as a result of the introduction of regional Rugby Union teams in Wales, the team started life with a third-place finish in the 2003/04 Celtic League and finished fourth the next season. In recent years, the team has struggled to compete successfully in major league and cup competitions. It is fair to say that this has not diminished the loyalty and support of their dedicated fans.

It is invidious to pick out the most famous modern players. The relative neutral selection on Wikipedia identifies four players from Newport Gwent Dragons who have been selected for the British and Irish Lions touring squads. They are Michael Owen, Gareth Cooper, Dan Lydiate and Taulupe Faletau.

Newport County AFC

Newport County Association Football Club (Welsh: Clwb Pel-droed Sir Casnewydd) is a professional association football club based in the city of Newport. The team play in League Two, the fourth tier of the English Football League system. Most recently reformed in 1989, the club is a continuation of the Newport County Club, which was founded in 1912 and was a founder member of the Football League's new Third Division in 1920.

Newport County were Welsh Cup winners in 1980 and subsequently reached the quarter-final of the UEFA Cup Winner's Cup in 1981. The club was relegated from the Football League in

Newport County AFC.

Newport County AFC 1977–78 Season 'Great Escape'.

1988 and went out of business in February 1989. The club reformed shortly afterwards and entered the English Football League system at a much lower level. In 2013, the club won promotion back to the Football League for the first time since 1988.

Popularly nicknamed 'The Exiles', Newport County is a team for whom the description 'chequered history' is more a reality than a cliché. After their apparent total demise in early 1989, the club was reformed in June of that year as Newport AFC, but playing 80 miles away in Moreton-in-Marsh, Gloucestershire. To some in Newport this was the equivalent of playing in Siberia or Outer Mongolia. There was a failed attempt to return to Newport in 1990 at Somerton Park, followed by a further period of exile in the city of Gloucester. Following legal action, the club came back to Newport in 1994 at the then newly built Newport Stadium, also known as Spytty Park, before transferring to Rodney Parade in 2013.

2010 Ryder Cup – Celtic Manor Resort
The 38th Ryder Cup was held 1–4 October 2010 at the Celtic Manor Resort in Newport. It was the seventeenth time the Ryder Cup had been staged in Britain, but the first time in Wales. It was played on the newly constructed *Twenty Ten* course, specifically designed for the event. The team captains were Colin Montgomerie for Europe and Corey Pavin for the United States.

With the US as the defending champion, Europe won by a score of 14.5 to 13.5 and regained the cup. It was Europe's sixth victory in the last eight contests and their fourth consecutive home win. The event was plagued by bad weather, with play having to be suspended twice. Having taken a three-point lead into the singles matches, Europe faced a US fight back and the conclusion of the Ryder Cup 2010 went right down to the anchor match between Graeme McDowell and Hunter Mahan. Eventually, McDowell defeated Mahan three and one to regain the cup for Europe.

As a result of the long suspension of play on the first day due to heavy rain, the format for the rest of the competition was changed to try to bring a conclusion to the matches on Sunday. However, further heavy rain caused a delayed start on Sunday, so that the last of the revised sessions would be played on Monday. Because of the changes, there were a number of Ryder Cup firsts. For the first time in the history of the Ryder Cup, all twenty-four players took part in pairing sessions at the same time in six pairings (as opposed to the usual four pairings) and in another first for the event, both foursome and four-ball matches were played in the same session at the same time. It is also the first time that the competition went into a fourth day. The revised schedule consisted of four sessions as opposed to the usual five.

The total number of each type of match remained the same: eight four-ball, eight foursomes and twelve singles. By captains' agreement, matches would conclude at sundown Monday if not completed before then. Any matches still in progress would be considered halved at that point.

The author well remembers the torrential downpours and the onset of fine weather heralding Europe's famous victory as well as the visit of US President Obama to the city.

Did You Know?

In September 2014 President Obama became the first sitting US president to visit Wales. He attended the NATO conference at the Celtic Manor Hotel, home of the 2010 Ryder Cup. In addition, he visited Mount Pleasant Primary School in the suburbs of Rogerstone. The president is on record with his appreciation of the warm welcome he received from the people of Newport and Cardiff.

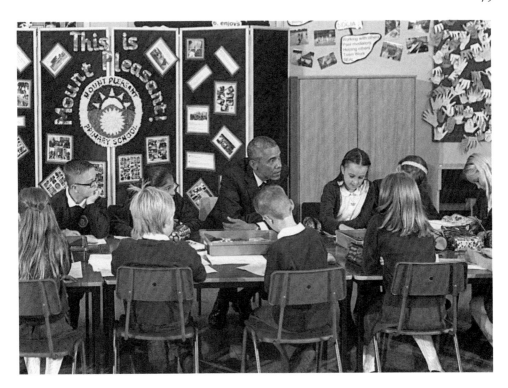

Above: President Obama. (Photographer unknown)

Below: The Celtic Manor Resort.

Art – Indoors and Outdoors

For works of art indoors in Newport, there is the Museum and Art Gallery in the city centre and the Civic Centre murals.

Newport Museum and Art Gallery was established in 1888, making it the second oldest in Wales after Swansea. Initially, it occupied successive sites in Dock Street but moved to its present location with the development of John Frost Square in the 1960s. The museum

tells the story of Newport's geological, archaeological and historical development. Among other treasures, it houses a nationally important collection of Roman and Romano-British archaeology from Caerwent and a major permanent exhibition on the Chartist rising in Newport in 1839. The art gallery possesses works by artists including L. S. Lowry, Turner, Picasso, Chagall and Stanley Spencer. Temporary exhibitions are also regularly held; recent subjects have included 'Worktown: The Art of Falcon Hildred'; and 'Newport and the First World War'. The murals on the four walls of the Civic Centre of Newport City Council were commissioned in 1960 with assistance from the Edwin Austin Abbey Memorial Trust Fund. They were conceived and painted by Hans Feibusch, assisted by Phyllis Bray and completed in 1964.

Outdoors, Newport City Council had produced an excellent guide to public art, which includes the following.

The Little Piggy
Celebrating over 700 years of markets in Newport, this is a life-sized bronze of a Gloucester Old Spot pig with baskets of fruit and vegetables.

Steel Wave
This award-winning sculpture, created by Peter Fink in 1991, stands in a prominent position on Newport's riverfront. Standing 40 feet high, the sculpture represents those steel and sea trades, which have played such important roles in Newport's development.

Stand and Stare
This sculpture was created by Paul Kincaid and commemorates Newport's 'Super Tramp' poet, W. H. Davies, whose poem 'Leisure' contains the famous lines 'what is this life if, full of care, we have no time to stand and stare'.

The Little Piggy.

Above Left: *Steel Wave.*

Above Right: *Stand and Stare.* (Photographer unknown)

Old Green Mural
The Old Green Mural depicts the Monmouthshire Railway & Canal Co. and the key role played by the canal and railway in Newport's rapid growth and prosperity in the mid-nineteenth century.

Sir Charles Morgan, 1760–1846
Sir Charles Morgan was an MP and wealthy landowner in Newport during the nineteenth century. This statue by J. E. Thomas was first placed in the High Street in 1850, but was removed ten years later. In 1992, it was returned to a prominent position in Bridge Street.

Did You Know?

The 1959 film *Tiger Bay*, based on Cardiff's Tiger Bay, was filmed partly on the Transporter Bridge. It starred Hayley Mills as twelve-year-old Gillie who witnesses a Polish sailor killing his girlfriend. Gillie manages to get hold of the gun, but when Superintendent Graham, played by John Mills, questions her, she invents stories that get her deeper into trouble. Hayley Mills is now Honorary Life Vice President of the Friends of Newport Transporter Bridge. Horst Buchholz, who played the Polish seaman Korchinsky, went on to take the part of Chico in the world famous film *Magnificent Seven*.

Old Green Mural.
(Photographer unknown)

Sir Charles Morgan.

Literature – Three Great Writers
Arthur Machen
Arthur Machen was a Welsh author and mystic of the 1890s and early twentieth century. He is now best known for his influential fantasy, supernatural and horror fiction. His novel, *The Great God Pan* (1894) has gained a reputation as a classic of the genre. As described in chapter 4 'Military Newport', he is well known for his leading role in creating the legend of the Angel of Mons.

Machen was born Arthur Llewelyn Jones in Caerleon, Monmouthshire, though he usually referred to the area by the name of the medieval Welsh kingdom, Gwent. The house of his birth, opposite the Olde Bull Inn in the Square at Caerleon, is adjacent to the Priory Hotel and is today marked with a commemorative blue plaque. The beautiful landscape of Monmouthshire, with its associations of Celtic, Roman and medieval history, made a powerful impression on him and his love of it is at the heart of many of his works.

Arthur Machen. (Photographer unknown)

Machen was descended from a long line of clergymen – the family having originated in Carmarthenshire. In 1864 when Machen was two, his father, John Edward Jones, became vicar of the parish of Llanddewi Fach with Llandegveth (around 5 miles north of Caerleon) and Machen was brought up at the rectory there. Jones had adopted his wife's maiden name, Machen, to inherit a legacy, legally becoming 'Jones-Machen'; his son was baptised under that name and later used a shortened version of his full name, Arthur Machen, as a pen name.

Finally, Machen accepted a full-time journalist's job at Alfred Harmsworth's *Evening News* in 1910. In February 1912, his son Hilary was born, followed by a daughter Janet in 1917. The coming of war in 1914 saw Machen return to public prominence for the first time in twenty years due to the publication of *The Bowmen* and the subsequent publicity surrounding the 'Angel of Mons' episode. He published a series of stories capitalising on this success, most of which were morale-boosting propaganda, but the most notable – *The Great Return* (1915) and the novella *The Terror* (1917) – were more accomplished. He also published a series of autobiographical articles during the war, later reprinted in book form as *Far Off Things*.

In general, though, Machen thoroughly disliked work at the newspaper and it was only the need to earn money for his family that kept him at it. The money came in useful, allowing

Did You Know?

Caerleon was home to Basque children who had been evacuated from the Spanish Civil War. A blue plaque on the façade of Pendragon House in Cross Street commemorates the house's role in sheltering Basque refugees from November 1939. Some 4,000 children had left northern Spain in May 1937 as the right-wing nationalists, aided by Spain's army and the fascist leaders of Germany and Italy, fought to oust the left-wing Republican government. Maria Fernandez, who had moved to Wales with her family some years earlier, became guardian of fifty-six of the child refugees at Cambria House. Shortly after the Second World War broke, thirty of the children and Mrs Fernandez moved to Pendragon House.

The children returned to Spain after the war, but Mrs Fernandez remained at Pendragon House until she was ninety-seven years old. She continued to receive updates from the former refugees, until her death in 2001.

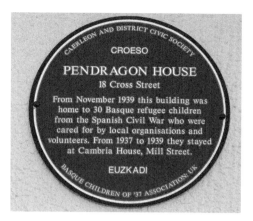

Basque children, Caerleon.
(Photographer unknown)

him to move in 1919 to a bigger house with a garden in St John's Wood, which became a noted location for literary gatherings attended by friends such as the painter Augustus John, D. B. Wyndham Lewis and Jerome K. Jerome. Machen's dismissal from the *Evening News* in 1921 came as a relief in one sense, though it caused financial problems. Machen, however, was recognised as a great Fleet Street character by his contemporaries and he remained in demand as an essay writer for much of the 1920s.

He enjoyed something of a boom in the 1920s, but this was not sustained in succeeding decades and he died almost in penury in 1947. However, no visit to Caerleon is complete without a pilgrimage to his birthplace and to Pendragon House.

Leslie Thomas

Leslie Thomas is the second Newport-born author. Very different from the life and times of Arthur Machen, Thomas is best known for his comic novel, *The Virgin Soldiers*. Born in 1931, he was orphaned at the age of twelve, when his mariner father was lost at sea and his mother died only a few months later from cancer. He was subsequently brought up in a Dr Barnardo's home; the story of this upbringing was the subject of his first autobiographical book, *This Time Next Week*.

Leslie Thomas. (Photographer unknown)

Thomas attended Kingston Technical School and he then took a course in journalism at South West Essex Technical College in Walthamstow. In 1949, he was called up for national service and embarked on a two-year tour of duty in Singapore with the Royal Army Pay Corps. While there he was briefly involved with the military action against communist rebels in the Malayan emergency. He also began to write short articles for publication in English newspapers.

On his return to England in 1951, Thomas resumed his work for the local newspaper group in north London, where he had worked before his national service, but within five years he was working for the Exchange Telegraph News Agency (Now Extel) and eventually with the *London Evening News* newspaper, first as sub-editor, later as a reporter. He stayed with the *Evening News* until 1965, when he embarked full-time on his writing career.

In 1984, Thomas published *In My Wildest Dreams*, recounting his childhood in South Wales, his days in Dr Barnardo's homes in London, his national service in the Far East and his career in journalism.

Thomas' novels about the 1950s British national service such as *The Virgin Soldiers* spawned two film versions in 1969 and 1977, while his *Tropic of Ruislip* and *Dangerous Davies, The Last Detective* have been adapted for television. He died in Wiltshire in 2014.

William Henry Davies

William Henry Davies wrote the poem 'Leisure', which famously begins, 'What is life if, full of care, we have no time to stand and stare.' The poem's theme is reflected in Davies' own outdoor life, which was unconventional. Leaving Wales, he worked and begged his way across America, losing a leg in an accident when jumping from a train. He returned to England and, unfit for work, dedicated himself to making a living as a writer. His first collection of poems attracted influential admirers, such as George Bernard Shaw, who helped Davies publish a successful memoir, *The Autobiography of a Super Tramp*, which dealt with his life travelling across America.

By 1929 his popularity and literary reputation led to the award of an honorary degree from the University of Wales and, ten years later, his home town of Newport unveiled a plaque in his honour at his presumed place of birth – the Church House Inn, Pillgwenlly. W. H. Davies was born in 1871 and died in 1940 in Nailsworth, Gloucestershire.

In the second volume of *Hando's Gwent*, local historian and folklorists paid tribute to Davies by quoting from several of the poems, including a lyrical description of moonlight on Newport

W. M. Henry Davies. (Photographer unknown)

Castle: 'The moonlight, like a big white butterfly, dreaming on that old castle near Caerleon, whilst at its side the UK went softy by.'

The son of an iron moulder, Davies was born at No. 6 Portland Street in the Pillgwenlly district of Newport. He had an older brother, Francis Gomer Boase (who was considered 'slow'), and in 1874 his younger sister Matilda was born.

In November 1874, when William was aged three, his father died. The following year his mother Mary Anne Davies remarried and became Mrs Joseph Hill. She agreed that care of the three children should pass to their paternal grandparents, Francis and Lydia Davies, who ran the nearby Church House Inn at No. 14 Portland Street. His grandfather Francis Boase Davies, originally from Cornwall, had been a sea captain.

In 1879 the family moved to Raglan Street, then later to Upper Lewis Street, from where William attended Temple School. In 1883, he moved to Alexandra Road School and the following year was arrested, as one of a gang of five schoolmates and charged with stealing handbags. Having finished school under the cloud of his theft, he worked first for an ironmonger. In November 1886, his grandmother signed the papers for Davies to begin a five-year apprenticeship to a local picture-frame maker. Davies never enjoyed the craft, however, and never settled into any regular work. He was a difficult and somewhat delinquent young man and made repeated requests to his grandmother to lend him the money to sail to America. When these were all refused, he eventually left Newport, took casual work and started to travel. *The Autobiography of a Super Tramp*, published in 1908, covers his life in the USA between 1893 and 1899, including many adventures and characters from his travels as a drifter. During this period, he crossed the Atlantic at least seven times, working on cattle ships. He travelled through many of the states, sometimes begging, sometimes taking seasonal work, but often ending up spending any savings on a drinking spree with a fellow traveller.

The turning point in Davies' life came when, after a week of rambling in London, he spotted a newspaper story about the riches to be made in Klondike and immediately set off to make his fortune in Canada. Attempting to jump a freight train at Renfrew, Ontario, on 20 March 1899 with fellow tramp 'Three-Fingered Jack', he lost his footing and his right foot was crushed under the wheels of the train. The leg had to be amputated below the knee and he wore a wooden leg thereafter. Davies' biographers have agreed that the significance of the accident should not be underestimated, even though Davies himself played down the story. Moult begins his biography with the incident and Stonesifer has suggested that this event, more than any other, led Davies to become a professional poet. Davies himself wrote of the accident:

I bore this accident with an outward fortitude that was far from the true state of my feelings. Thinking of my present helplessness caused me many a bitter moment, but I managed to impress all comers with a false indifference... I see soon home again, having been away less than four months; but all the wildness had been taken out of me and my adventures after this were not of my own seeking, but the result of circumstances.

Davies' view of his own disability was ambivalent. In his poem 'The Fog', published in the 1913 *Foliage*, a blind man leads the poet through the fog, showing the reader that one who is handicapped in one domain may well have a considerable advantage in another.

He returned to Britain, living a rough life, particularly in London shelters and dosshouses, including the Salvation Army hostel in Southwark known as 'The Ark', which he grew to despise. Fearing the contempt of his fellow tramps, he would often feign slumber in the corner of his dosshouse, mentally composing his poems and only later committing them to paper in private. At one stage he borrowed money to have his poems printed on loose sheets of paper, which he then tried to sell door-to-door through the streets of residential London. When this

W. H. DAVIES
from a portrait by Harold Knight

W. H. Davies. (Photographer unknown)

enterprise failed, he returned to his lodgings and, in a fit of rage, burned all of the printed sheets in the fire.

Davies self-published his first book of poetry, *The Soul's Destroyer*, in 1905, again by means of his own savings. It proved to be the beginning of success and a growing reputation. In order to even get the slim volume published, Davies had to forgo his allowance and live the life of a tramp for six months (with the first draft of the book hidden in his pocket), just to secure a loan of funds from his inheritance. When eventually published, the volume was largely ignored and he resorted to posting individual copies by hand to prospective wealthy customers chosen from the pages of *Who's Who*, asking them to send the price of the book, a half crown, in return. He eventually managed to sell sixty of the 200 copies printed. One of the copies was sent to Arthur Adcock, then a journalist with the *Daily Mail*. On reading the book, as he later wrote in his essay *Gods of Modern Grub Street*, Adcock said that he 'recognised that there were crudities and even doggerel in it, there was also in it some of the freshest and most magical poetry to be found in modern books'. He sent the price of the book and asked Davies to meet him. Adcock is still generally regarded as 'the man who discovered Davies'.

With the support of fellow poets Edward Thomas, W. H. Davies was settled in a rural cottage in Kent, when in 1907 *The Autobiography of a Super Tramp* was published. By 1914 Davies had moved to London, before marrying in 1923. He and his wife lived in various houses in the Home Counties, before 'settling at a series of five different residences' at Nailsworth, Gloucestershire. His last visit to Newport was in September 1938.

It is interesting to realise that Edward Thomas, who helped look after and foster the writings of W. H. Davies, went on to write *Adlestrop*. It is possible to imagine the two poets comparing notes about railways – dangerous riding freight trains in Ontario and sleepy railway stations in the Cotswolds.

At the end, W. H. Davies emerges from comparative secrecy as one of the most important Newportonians. He is commemorated in verse, in prose, in ceramic and bronze.

7. Newport Levels

This title encompasses an unknown corner of Newport, also called the Gwent Levels and variously Peterstone, Wentloog and Caldicot Levels, and, most recently, Living Levels. Described as 'an iconic landscape of international significance', communities have lived and worked here since the area was reclaimed from the Severn Estuary in Roman times. A hidden gem, the levels have wetlands and reens, traditional villages with ancient stone churches, evidence of historic disaster in the Great Flood of 1606/07; all of these are accessible on foot from the Wales Coast Path. According to its promoters, the Newport section of the Wales Coast runs for 23 miles from Peterstone Wentloog in the west to Redwick in the east via the Transporter Bridge or the City Bridge.

Technically, the Levels comprise two areas of low-lying alluvial wetland and intertidal mudflats either side of the Usk Estuary. They are entirely manmade and criss-crossed by artificial drainage channels known as 'reen' in Wales. They are ditches to convey and also to store water, holding water in the winter months when the sea doors are unable to discharge water due to being tide locked and in the summer months, to help stop adjacent ground from drying out. Their primary function is to move water 'from field to sea' during the wettest months of the year. Without this system, thousands of acres of prime agricultural land, homes and businesses would be flooded each year.

Conversely, the Newport Wetlands National Nature Reserve has extensive reed beds, shady woodland and varied habitats, which are home to lots of fascinating wildlife such as bearded

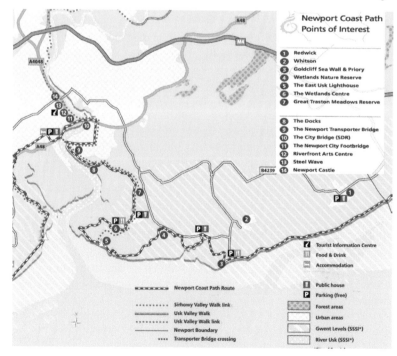

Newport Coast Path.

Right: Coast Path at Goldcliff.

Below: Newport Wetlands Visitors' Centre.

Bishton Crossing.

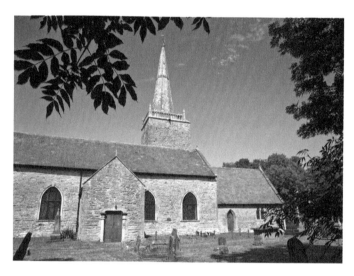

St Mary the Virgin, Nash.

tits, colourful dragonflies and rare, beautiful orchids. The visitors' centre has a café and information about four walks, namely the Sculpture, Orchid, Woodland and Estuary trails and the Wetlands experience.

In addition to walking the Wales Coastal Path, the author has found two other ways to visit the Levels. There is the closely guarded road crossing of the South Wales Main Line at Bishton. On the upper level there are gates with red warning discs. These discs are one of the longest lasting visual conventions on the railway, dating from an order of 1858. Use of this 'level crossing' requires some negotiation with the signallers in the adjacent box. When the gates are unlikely to be opened for some time, they recommend driving under the railway through the secret tunnel. This requires skill, daring and a small car to reach the magic world beyond the renowned Llanwern Steel Works.

The second alternative is to catch the Demand Responsive Transport buses from Newport's modern bus station. The DRT 62 goes to Redwick via Llanwern village and Bishton, while DRT 63 had two timetabled services each weekday to Whitson, Goldcliff and Nash. Both are invaluable for the intrepid explorer with a Welsh bus concessionary pass intending to visit the Rose Inn at Redwick, the Farmers Arms at Goldcliff, or the Waterloo at Nash. The last

of these is not to be confused with the Waterloo Hotel in Pill. The tour and description of significant churches located on the Levels, starts with St Mary the Virgin, Nash.

St Mary's Church dates back to around the twelfth century. The only remains of the Norman church is the north wall of the chancel and the squint, which was to enable persons with leprosy, small pox or other such diseases to see or participate in the service without endangering the congregation. During the 1500s, a new church was built off the old, with a fine tower of good proportions. This work was before the flood of 1606/07. Loss of life in Nash is not recorded, but the height of the water is marked on the base of the tower.

The tower is unusually located on the north side of the chancel – also note the stained glass in the east window, where the figures are portrayed in modern dress. The church underwent major restoration in 2004–05 and is now beautifully finished with a complete set of eighteenth-century furnishings with box pews, a three-decker pulpit and a western gallery.

St Mary Magdalene, Goldcliff, is a small church that dates back to 1424 when Goldcliff priory was destroyed by a flood. It is possible that some of the limestone blocks used to build this church came from the remains of the priory. The western tower seems to date from the eighteenth century or even as late as the early nineteenth century, and may be contemporary with the vaulted ceiling of the nave and chancel. The chancel arch is a Victorian insertion, the building having originally been a single cell. The tower contains one bell, recast by Tailors of Loughborough in 1969. The font is medieval and has an eighteenth-century cover. A brass on the north wall of the nave records the great flood of 1606/07 and the loss of property and life.

Goldcliff is also the site of a Benedictine monastery, founded in 1113 situated by Hill Far. At the time of the Dissolution, ownership of the parish, together with valuable salmon fishing rights, passed to Eton College. Goldcliff has long been associated with tidal 'putcher' fishing of salmon. These putcher baskets made of hazel rods and withy (willow) plait are set out against the tide in huge wooden 'ranks'.

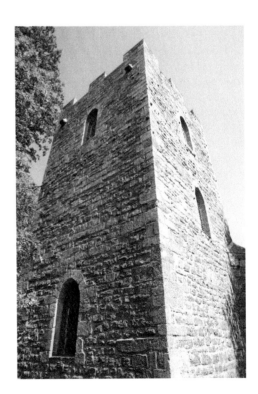

St Mary Magdalene, Goldcliff.

St Thomas the
Apostle and
Local Museum,
Redwick.

St Thomas the Apostle Church at Redwick is a large one for such a small village and has many points of interest. The building dates from the thirteenth and fifteenth centuries, and was restored by the architect John Norton in 1875 when the west wall was rebuilt and a large western window inserted. Look out for the thirteenth-century font, the unusual baptistery, the remains of a medieval rood screen and loft, along with the carving of a green man and the mass dials that have been scratched, indicating the height reached by the great flood of 1606/07. The church has been lovingly restored in recent years and among many projects has been the installation of the Victorian pipe organ in the north aisle and the restoration of the church bells in 1991.

Outside the church is the base and socket of a medieval wayside cross and a much restored three-step based cross. Completing the ensemble is an interesting secular building, partly formed from old stone, which serves as a bus shelter and museum, complete with cider press and old signs.

Whitson

Described as located in a 'little village', the medieval parish church is now closed. More imposing and visible is Whitson Court, formerly known as Whitson House. Its main claim to fame is that in the mid-twentieth century the grounds housed a zoological garden with bears, a lion, monkeys and exotic birds. A rare double for such a small village was that a small airfield operated at Upfield Farm between 1995 and 2009.

Did You Know?

The low-lying land around Newport suffered one of the worst natural disasters in recorded British history in January 1606 (Julian calendar Old Style). There were subsequently two calendar changes in 1752 for Great Britain; the first was to alter the start of the year from Lady Day (25th March) to 1 January, the second was to discard the Julian Calendar in favour of the New Style Gregorian Calendar. These changes mean that the disaster is now recorded as having taken place on 30th January 1607.

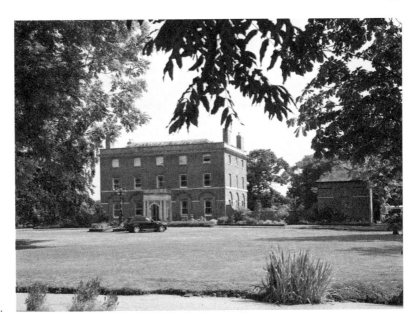

Whitson Court.

Bristol Channel Floods

The author has adopted the neutral description of this natural disaster on 30 January 1607, which drowned an estimated 2,000 people, destroyed livestock and inundated 200 square miles of farmland. Recent research has suggested that it may have been caused by a tsunami rather than a storm surge.

As can be seen at the churches in Goldcliff, Nash and Redwick, there are commemorative plaques up to 8 feet above sea level, showing how high the water rose. The plaques record the year as 1607 because under the Julian calendar – in use at the time – the New Year did not start until Lady Day on 25 March.

The cause of the flood, the worst natural disaster in British history, is not definitely known. Although contemporary explanations blamed God, modern scientific investigations have produced two compelling theories. The first of these is the 'storm surge hypothesis', which compared the 1606/07 high tides and probable extreme weather with the known, observed and recorded 1953 floods in East Anglia. The second hypothesis takes the written evidence from the seventeenth century and compares it to the 2004 Indian Ocean earthquake and tsunami. Key features include the sea receding before the wave arrived, a wave of water rushing in

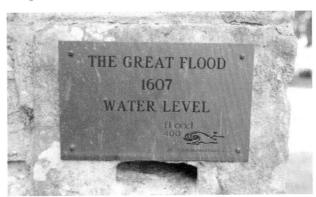

The Great Flood, 1607, Water Level, Nash.

The Author at Redwick Church.

Living Levels Newport.

faster than men could run, a description of the waves as 'dazzling, fiery mountains' and crowds of people who watched the wave coming towards them until it was too late to run. A BBC programme, *The Killer Wave of 1607,* exploring the theory was made as part of the *Timewatch* series. Although made prior to the 2004 tsunami disaster, it was not broadcast until 2005 with repeats in 2007 and 2017. The geological evidence neither contradicts nor endorses the tsunami theory, leaving scientists to investigate and romantics to speculate.

Living Levels

All those who love and visit the Levels can readily support the Living Levels Landscape Partnership, which includes the Royal Society for the Protection of Birds (RSPB) and Newport City Council and plans to reconnect people to these historic, vibrant and secretive places to give them a sustainable future. In common with this book, the Partnership aims to protect and tell the story of the unique land and waterscapes of the Levels.

Acknowledgements

I am extremely grateful to David Swidenbank, friend and photographer, for accompanying me on my visits in Newport. Unless stated, he is responsible for the pictures and deserves every credit.

I have appreciated particular help from Phil Cox, Chairman of Friends of Newport Ship, who arranged for the city of Newport to give permission to reproduce some key illustrations. The Friends ensure that the Ship Centre is open to visitors on a regular basis, as shown on their website.

We visited St Woolos Cathedral with the kind permission of the dean, Revd Lister Tonge, and with expert briefing from the administrator, Sian King. Our tour of St Woolos Cemetery was only possible thanks to the assistance of Charlie Dare, superintendent, and Christine Powell, clerk. Both are a credit to their employer, Newport City Council, and helped reveal a wealth of secrets, including Annie Brewer, John Byrne VC and John Jeremiah Lyons.

We found a similar treasure trove at Newport Docks thanks to Chris Green, port manager, and to Sue King. Thanks to the goodwill of Associated British Ports, we are able to use the archive photographs of Newport Docks and to share a selection of them with the United States Coastguard Service. When researching the story of SS *Indian Transport* I was aided by Tom Fowler of Radical Wales. Stephanie Roberts, mosaic sculptural artist, created the commemorative picture outside the Mission to Seafarers.

Close to the docks stands the Mission, whose chairman, Edward Watts, has been the source of unstinting help and encouragement. Edward led us deep into research about Newport heroes, not least Edward (Ted) Dyer, Wilbert Roy Widdicombe and Ivor John Tilley. Regarding the third of these, we were delighted to meet with Ivor's daughter, June Eacott, and her family, Rob George and Steve Clarke. June gave me a first-hand testimony of her father's exploits and character, as well as interesting artefacts and photographs. I regret that it was not possible to include everything in this book. Steve Clarke and Julie Nicholas pointed me in the direction of two more heroes, Perce Blackborow and Lady Rhondda. Julie Nicholas also produced the picture of Lady Rhondda.

More general thanks go to all who contributed to the chapter on Newport's heroes, especially Rhodri Clark at History Points and Shaun McGuire with Newport's War Dead.

For the section in 'Military Newport' on the Second World War British Resistance, I am heavily indebted to Sallie Mogford, county information officer, Coleshill Auxiliary Research Team (CART), Monmouthshire, for permission to use both text and photographs. Mrs Doris Mahon gave personal testimony about life in Pill in the 1930s and 1940s. Natural Resources Wales and Living Levels Landscape Partnership assisted in the material about the Wales Coast Path and the Levels.

Apricot Business Services expertly provided typing. Finally, I wish to thank my wife Jill and all my family for their support, patience and encouragement.

Bibliography

The primary sources for the research were:

Barber Chris, *Arthurian Caerleon*
Barber Chris (ed.), *Hando's Gwent, Volume 2*
Buckingham, Mime and Frame, Richard, *The Haunted Holy Ground*
Davies, W. H., *Autobiography of a Super Tramp*
Drysdale, Ann, *Real Newport*
Finch, Peter, *Edging the Estuary*
Hall, Mike, *The Severn Tsunami?*
Hutton, John, *The Newport Docks & Railway Company*
John, Angel, V., *Turning the Tide – The Life of Lady Rhondda*
Jordan, Christine, *Secret Gloucester*
Matthews, James, *Historic Newport*
Newport Museum & Art Gallery, *The Gun Factory*
Newman, John, *The Buildings of Wales, Gwent/Monmouthshire*
Preece, Jan, *Newport through Time*
Trett, Bob, *Newport, a History & Celebration*
www.abports.co.uk/Our_Locations/SouthWales/Newport
www.coleshillhouse.com, 'British Resistance Archive'
www.fontsb.org.uk – 'Friends of Newport Transporter Bridge'
www.historypoints.org
www.hlf.org.uk/out_project/living-levels-partnership – 'Newport Levels'
www.missiontoseafarers
www,newportcathedral.org.uk
www.newportpast.com
www.newport.gov.uk/heritage/Museum
www.newportsdead.shaunmcguire.co.uk
www.newportship.org
www.rspb.org.uk – 'Newport Wetlands'
www.walescoastpath.gov.uk – 'South Wales Coast Severn Estuary'